LEONARDO DA VINCI

Renaissance Genius

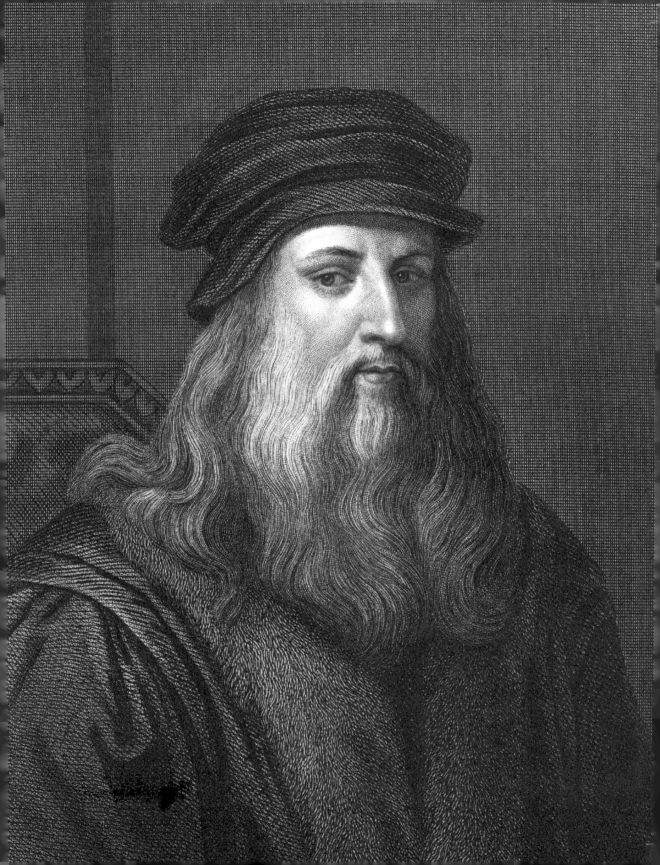

LEONARDO DA VINCI
Renaissance Genius

Barbara O'Connor

 Carolrhoda Books, Inc./Minneapolis

For Janet

Carolrhoda Books, Inc.
A division of Lerner Publishing Group
241 First Avenue North
Minneapolis, MN 55401 U.S.A.

Website address: www.lernerbooks.com

Library of Congress Cataloging-in-Publication Data

O'Connor, Barbara.
 Leonardo da Vinci / by Barbara O'Connor.
 p. cm.
 Includes bibliographical references and index.
 Summary: A biography of the notable Italian Renaissance artist, scientist, and inventor.
 ISBN: 0-87614-467-9 (lib. bdg. : alk. paper)
 1. Leonardo, da Vinci, 1452–1519—Juvenile literature. 2. Artists—Italy—Biography—Juvenile literature. [1. Leonardo, da Vinci, 1452–1519. 2. Artists. 3. Painting, Italian. 4. Art appreciation.] I. Title.
 N6923.L33 O27 2003
 709'.2—dc21 2001006470

Manufactured in the United States of America
1 2 3 4 5 6 – JR – 08 07 06 05 04 03

CONTENTS

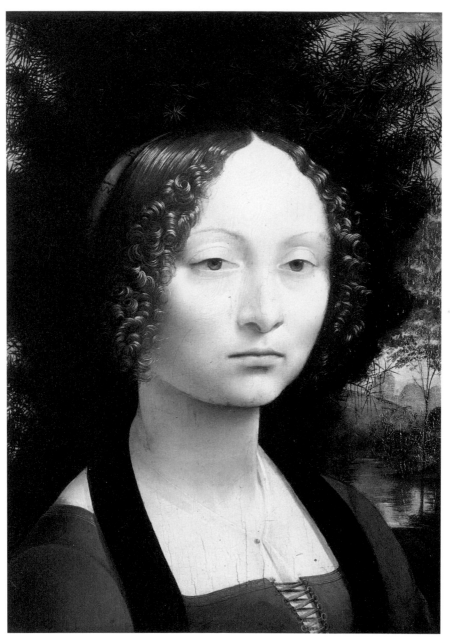

Leonardo's portrait *Ginevra de'Benci* was painted in about 1476. Much of what we know about Leonardo is based on the extraordinary artwork, writing, and ideas he left behind.

Author's Note

Leonardo is considered one of the world's greatest artists. His scientific discoveries and inventions amaze historians and scientists alike. We know of many of his achievements, but much of his life remains a mystery.

Leonardo lived over five hundred years ago, and there are very few documented facts about his life. The artist himself left behind few clues. During his lifetime, he kept thousands of pages of notes containing drawings, inventions, opinions, observations, and letters. From his notes, we have learned much about his ideas and accomplishments. Unfortunately, his notes reveal almost nothing about Leonardo as a person—his daily life, his personality, or his emotions.

The first biography of Leonardo da Vinci was written almost fifty years after his death by the artist, architect, and writer Giorgio Vasari. Vasari collected stories about Leonardo from Leonardo's former pupils and friends. His biography was published as part of a volume titled *Lives of the Painters, Sculptors and Architects*. It is a valuable description of Leonardo's life. However, most modern historians believe the biography contains mistakes, incorrect information, and exaggerated legends.

Since the completion of Vasari's biography in 1568, biographers have tried to piece together a more accurate picture of the life of Leonardo da Vinci. However, with few remaining historical documents, biographers don't always agree on some of the facts surrounding this famous artist and scientist.

When researching information for this biography, it became obvious that much of what is published about Leonardo da Vinci is a patchwork of recorded facts and educated guesses. As a biographer, I have chosen to include as much documented information as possible. I have also tried to inform the reader when a detail is uncertain or when a story about the artist may simply be a colorful legend passed down through the years. In doing this, my goal has been to paint the clearest portrait possible of a remarkable artist, scientist, and inventor.

1

A Country Boy

On a peaceful hillside in Italy in the middle of the 1400s, a young boy strolled with his uncle among the tangled grapevines and silvery-green olive trees. Above them was the village of Vinci, with its small stone houses huddled around an ancient castle. Below them, the Arno River wound its way through the Tuscan Valley.

The boy and his uncle may have stopped to gather rocks and plants to carry home. They might have captured lizards in the vineyards. Perhaps they just lay on their backs in the wheat fields and studied the birds that flew above them. At the end of the day, the two made their way back up the dusty road to the family farm in the nearby hamlet of Anchiano.

The boy's name was Leonardo. Because his family had lived in the town of Vinci for many generations, they had taken the surname "da Vinci," Italian for "of Vinci." The boy, then, was Leonardo da Vinci.

Back in his family's farmhouse, Leonardo might have hurried to show his rocks to his grandfather, Antonio. He might have told his grandmother, Monna Lucia, about the birds he had seen. Then he may have sat by the fireplace and listened to his Uncle Francesco tell him about how some plants could be used for medicine or how the clouds could help a person predict the weather. Leonardo adored Francesco and must have thought his uncle knew all there was to know about nature and the world around him.

Although there are few documented facts about Leonardo's childhood, one thing is certain. He was born on April 15, 1452, at 10:30 P.M. His grandfather, Antonio da Vinci, entered the date and time in the family's leather-bound book when Leonardo was baptized in the village

Some historians believe Leonardo was born in this cottage in the Italian village of Vinci.

The lovely countryside surrounding Vinci brought Leonardo much joy as a child and gave him a lifelong passion for the natural world.

church. "There was born to me a grandson, the child of Ser Piero my son," he wrote. Antonio also entered the names of the priest and the villagers who witnessed the baptism. He did not, however, record the name of Leonardo's mother, Caterina. She and Ser Piero were not married, so baby Leonardo was considered illegitimate. In those days, it was not unusual for the mother to be omitted from the family records if she had given birth to an illegitimate child.

Piero da Vinci's status as a wealthy notary allowed him to use the title "Ser" before his name. As a notary, Ser Piero prepared contracts and other legal documents for people who paid him well. Ser Piero was a stern and ambitious man whose career kept him in Florence, twenty miles away, and left little time for raising Leonardo.

Caterina was most likely a peasant, not from the kind of reputable family that Ser Piero expected to marry into. Within months after his son's birth, Ser Piero married Albiera di Giovanni Amadori, the daughter of a Florentine notary. He must have considered Albiera a more suitable wife for a well-to-do businessman like himself.

It seems likely that the infant Leonardo stayed with Caterina, close to his grandfather Antonio in Anchiano. He and Caterina may even have lived in a cottage provided for them by Leonardo's family. Later, however, possibly when Leonardo was about eighteen months old, the Da Vincis arranged for Caterina to marry a laborer nicknamed the Quarreler. After the marriage, Caterina went to live with her new husband in a nearby village. Young Leonardo was left with his aging grandparents, Antonio and Monna Lucia.

The elder Da Vincis took good care of Leonardo, but it was Ser Piero's younger brother, Francesco, who gave Leonardo the time and attention the small boy needed. Francesco was a gentle young man, content with his country lifestyle and satisfied with overseeing the family farm. He was happy to have Leonardo's company as he tended the crops and animals. When the chores were done, the two set off to explore the fields and woods. It was probably Francesco who answered the questions of a curious young Leonardo. What were the names of the wild herbs in the fields? How did the small creatures in the woods survive? How were the seasons different? When would the weather change? Roaming the hillsides with Francesco, Leonardo must have made some of his

first observations about nature: the shapes of leaves, the colors of the sky, the flight of birds, and the flowing water of a rocky stream.

While Leonardo had the love of his uncle and grandparents, he probably felt confused about his mother and father. Not long after her marriage to the Quarreler, Caterina had another child. Three more followed close behind. It is likely that Leonardo saw his mother and her children in Vinci on special occasions, such as at feasts and fairs or on market days. Those brief meetings were likely the only relationship young Leonardo had with his mother. His father, Ser Piero, stayed too busy with his prosperous business and his new wife in Florence to find time for Leonardo. He sent money for his son's upkeep, but his visits to Vinci were rare and brief.

As the son of a successful notary, Leonardo should have been sent to one of the best schools in Florence. There he would have learned literature, Latin, geometry, and physics. He also would have been forced to stop writing with his left hand because left-handed people were thought to be possessed by the devil. But such an education was not available to illegitimate children like Leonardo. Instead, he had to settle for whatever schooling the village priest and his uncle and grandfather could give him. He learned to read and write. He learned basic arithmetic using an abacus, a small frame with beads for counting. He may have read passages from the Bible. And he continued to write with his left hand.

In about 1465, when he was a young teenager, Leonardo's life changed. He left the quiet, predictable

comfort of Vinci and began a new life in the big city of Florence, a day's journey on horseback. Along with Rome, Venice, and Milan, Florence was one of the most powerful city-states in Italy. Each independent city-state had its own ruler, government, and army. These city-states were not unified into a single country. Instead, they were often at war with one another or other nations.

No one knows exactly when or why Leonardo left Vinci for Florence, but there were several reasons to send the boy away. His uncle, Francesco, got married sometime in the late 1460s. Piero's wife, Albiera, died in 1464, and Piero remarried a year later. Whatever the reason, Leonardo left the quiet country village of his childhood. He was probably at the age of about twelve or thirteen.

Leonardo arrived in Florence at one of the most exciting times in European history: the Renaissance. Renaissance means "rebirth" in French. It was a period in Europe that began in Italy in the 1300s and lasted for more than three hundred years. The Middle Ages was the period before the Renaissance. This period lasted for about one thousand years. It was a time of war, disease, and famine. Few people could read or write. Art and education were controlled by the Catholic Church, which had great power in Europe. Creativity and new ideas outside of the Church were not welcomed and were often met with suspicion.

During the Renaissance, people broke away from the narrow focus of the Middle Ages. Instead, they returned to forgotten ideas developed centuries before in ancient

Greek and Roman societies. Like the Greeks and Romans, people of the Renaissance questioned, explored, experimented, and developed new ideas. Artists, scholars, and scientists found new ways of thinking and expressing themselves. Around 1450 the printing press developed by Johannes Gutenberg made millions of books available for the first time in history. The invention helped spread the new ideas and discoveries throughout Europe.

To a country boy from the tiny village of Vinci, Renaissance Florence must have seemed like another world. A lively and prosperous city, Florence was the center of the Renaissance movement. It was known for its creative atmosphere, where new ideas in art and science were welcomed. By the time Leonardo arrived in Florence, the

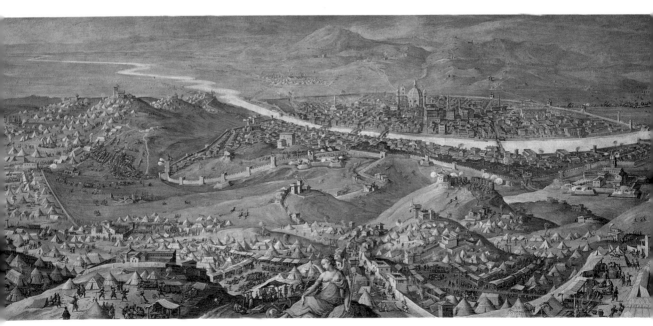

Leonardo's first biographer, Giorgio Vasari, painted this view of Florence during the Renaissance.

city had been ruled for nearly thirty years by the Medici family. Besides being rich and powerful, the Medicis were great lovers of the arts. They used their influence to attract painters, sculptors, poets, and scholars to Florence.

Florence was also a trade center crowded with shops, banks, churches, and houses. On his first walk through the city, Leonardo would have seen streets wide enough for four donkey-driven carts to fit side-by-side. Along the sidewalks, vendors sold exotic spices, dyed silks, and colorful fruits and vegetables. He would have seen shops where craftsmen created the finest works of art for the city's churches and palaces. His walk would have eventually led him to the Ponte Vecchio. This bridge spanned the Arno River, the same river where he had played as a boy in the valley below Vinci.

To be in such an exciting city at such an exciting time should have meant that there were many opportunities for Leonardo. But because he was illegitimate, Leonardo was not allowed to attend the university. With that door closed to him, he would never become a notary, like his father. Nor would he be a banker or a doctor or any other well-respected profession that required higher education. Ser Piero had to make a decision about what to do with his young son.

It was common for the working class and poor to send their young sons to work as apprentices for masters skilled in a trade. For a small fee, the apprentice was taught the techniques of his master. He might learn how to make shoes, furniture, or art. In addition to learning the trade, apprentices did chores in exchange for lodging,

food, and clothing. Over a period of about six years, an apprentice worked his way up to the status of assistant, then eventually to master. Although the Da Vincis were not poor, apprenticeship seemed like the only choice for Leonardo.

Ser Piero's business brought him into contact with many important people in Florence, including the well-known painter and sculptor Andrea del Verrocchio. Piero knew that talented artists from all over Italy came to Florence in hopes of finding a position as an apprentice in Verrocchio's workshop.

Piero took Leonardo to visit Verrocchio and arranged for his son to become an apprentice to the famous artist. While there is no record of Leonardo's interest in art as a young child, it is possible that he had begun to show talent in drawing early on. Some historians believe that Piero may have shown Verrocchio some of Leonardo's drawings, and that the artist was so impressed with them that he offered Leonardo a position.

With few other choices available to him, sometime between 1465 and 1467, Leonardo da Vinci went to live in the artist's studio. It would change his life forever.

2
An Artist's Apprentice

Leonardo's new home was not like anything he had ever known before. Gone were the quiet days and idle hours of his country life in Vinci. Now he would live with the other apprentices in a cramped wooden building on one of Florence's busiest streets. Unlike the peaceful farmhouse of Leonardo's youth, Verrocchio's workshop, or *bottega* as it was called in Italian, was filled with noise and activity. The door to the main workroom opened directly onto the street, allowing dogs, pigs, and chickens to run in and scurry about freely.

Verrocchio's bottega was one of the busiest in Florence. In those days, artists produced works of art because they were hired, or commissioned, to do so. Sometimes the person who hired them, the patron, was a wealthy merchant wanting a portrait of his wife or of himself. Often, the patron was a monk or priest in need of a religious sculpture for a church entrance or a painted screen behind an altar, called an altarpiece. Verrocchio was a skilled and energetic craftsman willing to take on whatever work

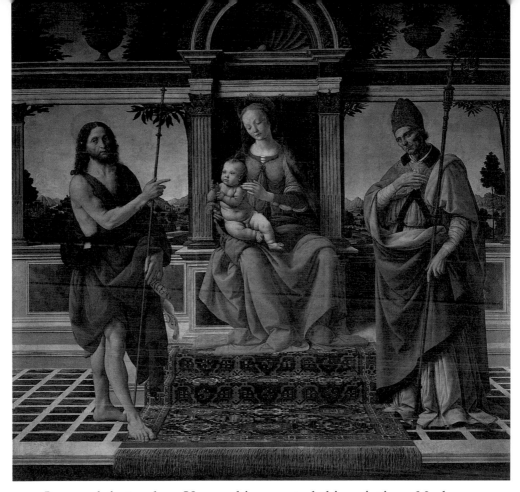

Leonardo's teacher, Verrocchio, created this painting, *Madonna and Child Enthroned between Saints John the Baptist and Zeno.*

came his way, from paintings and bronze statues to coats of arms, masks, parade floats, or designs for machinery. He and his apprentices worked as a team to complete the various commissions the workshop received. The artists rarely signed their names to their work. It wasn't important who did the painting or sculpture, just that it was done as the patron wanted.

Leonardo had only to look around him to see that there was much to learn from his new master. In the main room of the bottega, the young artist saw some of his new

teacher's assistants painting huge wooden panels covered with a fine white plaster mixture called gesso. Other assistants were hammering metal into elaborate armor. He saw others cutting gems or carving ivory for finely crafted jewelry. The older apprentices tended the fiery kilns used to harden clay sculptures. They also tinted paper or ground stone into pigment to make colors for paint. The younger apprentices, like himself, swept the floors and cleaned brushes and mallets.

As the newest member of the bottega, Leonardo knew nothing about the art techniques he saw being practiced around him. But he had a sharp mind, an eager curiosity, and one of the finest teachers in Florence. In addition to his talent in painting and sculpting, Verrocchio was a skilled goldsmith, musician, and mathematician. He took an instant liking to his new apprentice. The master artist recognized Leonardo's eagerness to learn and was amused by his country ways and sometimes rebellious spirit.

Leonardo's days in the bottega were long and busy. He worked for twelve hours each day before retiring upstairs to sleep on the straw-covered floor. Like all new apprentices, he started his training by doing simple chores. He swept, cleaned, mixed paints, and ran errands. Soon, however, he began to learn the skills he would need to work his way up from apprentice to master craftsman. He made brushes from animal fur and pens from goose quills. From sprigs of grapevine, he prepared charcoal for drawing. He helped apply plaster to walls for murals called frescoes. He learned how to mix egg yolk with ground pigments to make a paint called tempera and how

to prepare wax needed for sculpture. He even mastered the skills of goldsmithing and metalwork.

Leonardo began his apprenticeship at a time when art was changing dramatically. Before the Renaissance, paintings often looked flat and not very realistic. Most artists in the Middle Ages were not interested in painting lifelike humans or nature scenes. They were more focused on painting images in a way that would give their work a religious meaning. By the time Leonardo came to Verrocchio's bottega, art had become more lifelike. Verrocchio taught his artists to be precise, to paint and sculpt exactly what they saw. He provided plaster casts of hands, feet, legs, and torsos so Leonardo and the others could observe and draw them. He smeared fabric with clay to make it stiff and heavy, then arranged it in drapes for the artists to study and paint.

Verrocchio also taught his students to use a new technique called perspective. This technique allowed artists to make the background of a painting look farther away than the foreground. It also helped artists make objects and people appear three-dimensional. Verrocchio taught his pupils to use geometry, mathematics, and shading to create perspective in their work. Leonardo may not have been able to attend a university, but he was getting a fine education from his teacher.

But life in the bottega offered Leonardo more than just an education in art. Often, writers, scholars, and artists gathered in the workshop to exchange news or share ideas. They talked about music, books, science, and philosophy. Leonardo relished the intellectual atmosphere.

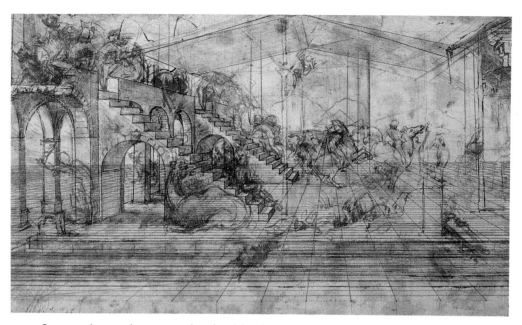

Leonardo used perspective in this sketch he made for *Adoration of the Magi,* a later work. To make his painting look three dimensional, he used mathematics to measure where people and objects should go and how big or small they needed to be.

From his first days in the bottega, Leonardo showed both an ability to learn quickly and a natural talent in art. Eventually, he was allowed to transfer Verrocchio's drawings onto walls or wooden panels or to put down the first layers of paint on a fresco. As Leonardo became more skilled, he took on more demanding jobs. It was common for more experienced apprentices to draw or paint small portions of the master's work. Verrocchio watched Leonardo's progress and eventually assigned him tasks that required more artistic skill, such as painting backgrounds or adding plants or other small objects to a painting.

Word of Leonardo's talent must have traveled to the young man's father. According to one story, not long

after Leonardo began his apprenticeship, Piero requested that his son produce a work of art. A worker from Piero's estate in Vinci had asked Leonardo's father to recommend an artist to paint a round, wooden shield he had carved from a fig tree. Piero took the shield to his son. Leonardo decided that the best image to paint on the shield would be a scary beast of some sort. But he wasn't content to just use his imagination. Leonardo set to work collecting lizards, grasshoppers, snakes, bats, crickets, and other creatures he could observe and study. He cut them up, adding parts of one to parts of another, until he had a fantastic dragonlike creature to copy.

Leonardo depicted his imaginary beast coming out of a cave and breathing flames, its eyes glowing fiercely. When he was done, he invited his father to come inspect it. He propped the painted shield on his easel in a darkened corner of the room. Only a small ray of light from the window shined on it. Leonardo waited out of sight while Piero entered the room. The painted beast looked so lifelike that at first Piero was quite frightened. Leonardo was delighted. According to the story, Piero was so impressed with the magnificent shield that he sold it to a Florentine merchant for a handsome sum of money and bought a cheap painted shield to return to the worker. It is said that the duke of Milan later bought Leonardo's painted shield for an even larger sum.

Whether or not this story is true, Leonardo showed both talent and a playful, rebellious spirit from his earliest days with Verrocchio. As he began to work more independently, Leonardo preferred to do things his own way.

He wasn't content to follow the techniques handed down to him. He liked to find new ways of doing things.

Leonardo was especially interested in experimenting with making and using oil paints. Oil paints were a recent invention, and Italian artists had not had much experience using them. While most of Verrocchio's students made their oil paints exactly as they were told, Leonardo spent hours mixing pigments with Verrocchio's linseed or walnut oils to come up with his own recipes for paint. He was always looking for new and better combinations. Soon he became one of the best in the bottega at using oil paints.

Leonardo was lucky to have a teacher who admired his independent nature and encouraged creativity and experimentation. Fifteenth-century artists weren't expected to have a unique style. They were hired to create a piece of art strictly according to the wishes of the patron. Often, the patron specified every detail in a contract, from the exact figures to be drawn to the quality and type of materials to be used. Usually, the assistants in a bottega were expected to imitate the master.

But Leonardo wasn't content to imitate Verrocchio. He wanted his work to reflect his own style. Years later he would write, "The painter will produce mediocre pictures if he is inspired by the works of others."

As Leonardo took on more and more responsibility in the bottega, he found he had little free time. Once in a while, however, he had a chance to explore the city. Although he must have missed the woods and fields of his boyhood home in Vinci, he loved the fast-paced city life of Florence. Strolling the sidewalks, dressed in a

short tunic, Leonardo had an air of confidence. Handsome and outgoing, he liked to visit artists from other bottegas to chat about events of the day or discuss art. Sometimes he went to churches or palaces to study the sculptures and paintings of other artists. He was fascinated by everything around him, from the architecture of the grand palaces to the faces of the shoppers who strolled through the marketplace.

Within six years, Leonardo had completed his training and earned the title of master craftsman. In 1472, at the age of twenty, he joined the painter's guild. A guild was an organization of members of a trade, such as goldsmiths or bakers. The guild worked to protect the rights and work conditions of its members. Leonardo registered his name, with the title of master, as a member of the painter's guild, the Company of Saint Luke.

About the same time that he earned the title of master, Leonardo assisted Verrocchio on a painting. It was commissioned by the monks of San Salvi, a monastery just outside the city walls of Florence. The painting, called *Baptism of Christ,* is the oldest surviving example of Leonardo's work. It shows Christ being baptized by Saint John the Baptist while two angels look on. Leonardo painted one of the angels, as well as the background.

Leonardo's memories of the natural beauty of Vinci were etched in his mind forever. In the background of *Baptism of Christ,* Leonardo painted perfectly the rough surface of the rocks and the clear flowing water he remembered from his youth. His background looked more realistic than the rigid trees and rocks that Verrocchio had

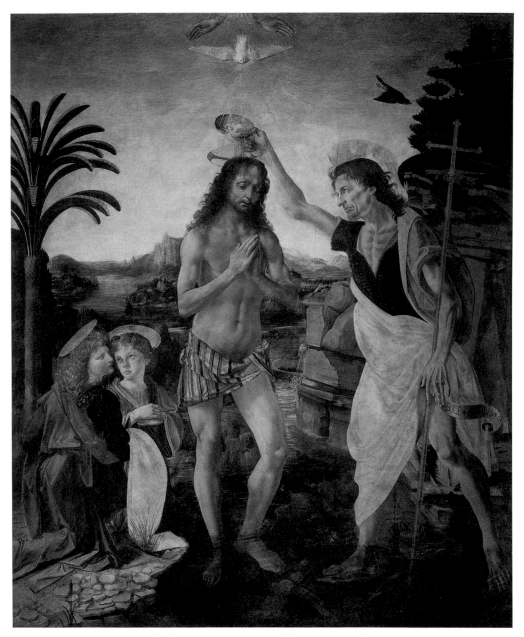

When *Baptism of Christ* was X-rayed in modern times, art scholars could see how superior young Leonardo's technique was to that of his master's. Leonardo's angel *(far left)* is painted with many layers of paint so thin and smooth that no brush strokes show.

made in the middle ground of the painting. Leonardo also used perspective. He wanted the images in the background to appear far in the distance. He did this in part by using pale colors and making the nature scene look less focused than the rest of the painting.

Leonardo knew that he wanted his angel to be a three-dimensional figure, not a flat picture on a flat surface. The most common type of paint used by artists at that time was tempera paint, made with water and egg yolk. Tempera paints dry very quickly, so the artist had to make corrections by painting over the original. Leonardo did not use tempera paint. He used his oil paints.

Oil paints dry slowly. While oil paint is still moist, an artist can blend and alter it on the painting surface. By using this new kind of paint, Leonardo could work on his composition slowly and make changes as he went along. His paints were perfect for achieving the three-dimensional look that he wanted. First, he applied a coat of light paint. Next he added darker layers, with contours and shadows. He applied each layer carefully and smoothly, so that no brush strokes would be seen. When he was finished, the little angel appeared lifelike. Unlike the dull figures painted by Verrocchio, Leonardo's angel seemed to glow with a soft, divine light.

Leonardo's portion of *Baptism of Christ* is remarkable in its delicate beauty. According to one story, when Verrocchio saw the detail, realism, and near perfection of Leonardo's angel, he vowed never to touch a paintbrush again. Whether or not the story is true, it was clear that Leonardo had surpassed his master in artistic ability.

3

On His Own

In the summer of 1473, twenty-one-year-old Leonardo escaped the sweltering heat of Florence to return to Vinci for a brief visit. Back in the peace and serenity of the countryside, he once again roamed the hills, vineyards, and fields of his youth. Leonardo recorded his visit by sketching two landscapes. His pen and ink sketches depicted the rugged, terraced hillsides, and the waterfalls, rocks, and streams of the Vinci countryside in great detail and with remarkable accuracy.

These landscapes are Leonardo's earliest known drawings. He rarely dated his art, but these sketches may have been special to him. He dated one of them August 5, 1473, and wrote on the back of it, "I, stopping at Antonio's, am content." The drawings reflect his love of nature and a strong attachment to his childhood home. Leonardo wanted the rocks, water, and trees that he saw

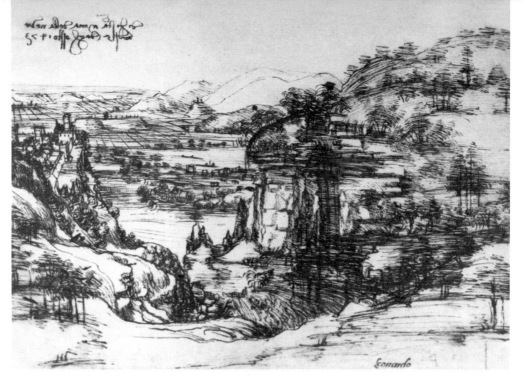

The water and plants that Leonardo sketched in this drawing on August 5, 1473, became common backgrounds in his later paintings.

with his eyes to come to life on paper. His drawings create a sense of motion. The water seems to be flowing and the grass and trees look as though they are blowing in the wind.

Leonardo enjoyed the quiet solitude of Vinci, but he was probably glad to return to Florence. He loved the excitement of the city and the stimulating atmosphere of the bottega. Smart and curious, Leonardo was always looking for the next new thing to experiment with, to study, or to paint. If forced to linger too long on one thing, he became bored. The variety of activities in Verrocchio's bottega suited him perfectly.

Verrocchio received commissions from patrons all over the city, including the Florentine ruler Lorenzo de' Medici, often called Lorenzo the Magnificent. Like his

father and grandfather before him, Lorenzo loved art, music, and poetry. He kept Leonardo and the other artists in Florence busy painting, sculpting, making banners, building floats, and designing stages used for entertaining.

By the early 1470s, Leonardo had been with Verrocchio for nearly ten years and had risen to the status of chief assistant. He seemed content to stay in the bottega rather than leave to set up a workshop of his own. With Verrocchio, Leonardo had financial security, as well as constant companionship. He made friends easily and enjoyed the company of others. When the artists gathered at the end of the day, Leonardo often entertained them with jokes, funny stories, and clever tricks. He was particularly good at making stinkballs out of dead fish! He also had a fine singing voice and a talent for playing the *lira da braccio,* an instrument that resembled a viol, played with a bow.

On his own, Leonardo practiced his drawing every chance he got. He drew objects and people from every angle. He drew things that were far away and close up, observing how an object looked smaller the farther away it was. He drew in both bright and dim light, with varying shades and shadows. He sketched a subject over and over again, filling every inch of space on the paper.

Leonardo observed everything around him and never missed an opportunity to find a model for his realistic drawings. As he drew, his mind raced from one idea to the next. He copied the facial expressions of the shoppers in the marketplace. He drew the horses that trotted and pranced down the streets of the city. He sketched the cats playing, pouncing, and scampering about the bottega.

Often, he couldn't resist the urge to let his imagination have a little fun. His mind, too, was lively and playful. Right in the middle of his sketches of cats, for instance, he drew a tiny dragon.

Somewhere between 1474 and 1475, Leonardo and several other artists in Verrocchio's studio worked on the *Annunciation.* This painting shows the archangel Gabriel announcing to Mary that she will give birth to a son named Jesus. Each artist added something to the painting, but Leonardo most likely designed, sketched, and painted a large portion of the work. When he painted the angel's wings, he thought of all the birds he had observed and sketched. He painted the plants and flowers with careful attention to detail. And he based the clothing worn by Mary and Gabriel on the many sketches he had made of fabric in Verrocchio's workshop.

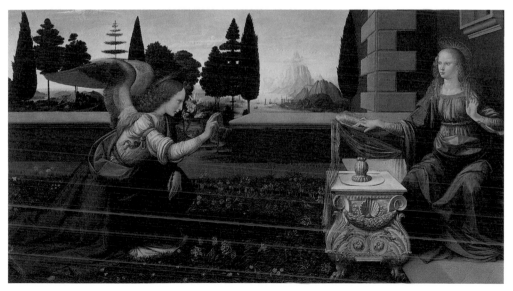

Leonardo's *Annunciation*

By 1477 Leonardo had begun to feel the tug of independence. He was restless and dissatisfied with his life in the bottega. At the age of twenty-five, Leonardo had spent nearly half his life with Verrocchio. He realized that he was no longer content to work on pieces that were not his own. Maybe he was also beginning to realize how quickly the years were passing. "Nothing flows faster than the years, daughter of time," he once wrote. By the end of the year, Leonardo had decided to leave Verrocchio's bottega.

For the first time in his life, Leonardo was on his own. Without the financial security of the bottega, he would have to find work. On January 1, 1478, Leonardo got his first commission as an independent artist, from the government of Florence. He received an advance payment for an altarpiece to be painted in a chapel in nearby Signoria. He started the piece but, for some reason, never finished it.

When Leonardo received a commission for a painting, he always started out enthusiastically. He loved the first stages of the work. He spent weeks and sometimes months planning the organization of the piece. He worked out the perspective for the piece using mathematics. And he often did hundreds of sketches before deciding on the final arrangement. Where would each figure be placed? Would the subject be sitting or standing? What should he paint in the background?

Once he was satisfied with his composition, he began the cartoon, a drawing on paper from which the actual painting would be made. Next, he attached the cartoon to the wooden panel or wall on which he was planning to do

the painting. He then punched holes along the outline of the drawing. After that he used black chalk to mark on the wall or panel through the holes in the paper. Finally he was ready to start painting. He first applied a coat of oil paint called the underpainting, adding shadows in dark tones. Once the underpainting was dry, he was ready to begin painting his composition with layers of oil paint.

The process was long and tedious. Leonardo worked slowly, not satisfied until each step was perfect. Often, he abandoned a project long before it was complete. Perhaps he got bored with it. Perhaps he found other projects that were more interesting. Whatever the reason, he sometimes frustrated his patrons and began to acquire a reputation as an unreliable, though talented, artist.

It became obvious from Leonardo's first months as an independent artist that his talents were with painting, not business. He had no interest in money and ignored offers or left jobs unfinished time after time. He refused to be treated merely as a laborer simply following the directions of those who hired him. He wanted his patrons to respect him as a creative artist. Why should he be content to copy others or paint only what he was told? He wanted to try new ideas and create new images. This rebelliousness and independence often left his patrons unhappy with his work.

In March 1481, Leonardo signed a contract with the monks from a convent just outside Florence. He must have been anxious to work, for he agreed to receive payment in the form of land rather than money. He also agreed to pay for his own paints and gold leaf and to finish

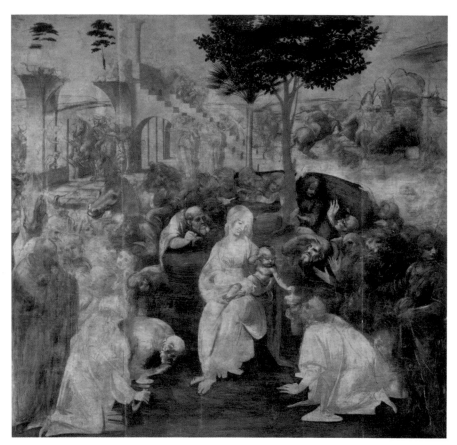

Leonardo's *Adoration of the Magi.* Unlike most artists of his time, he chose not to paint halos over Mary or the baby Jesus.

the altarpiece within twenty-four to thirty months. He sketched hundreds of drawings to prepare for the painting, which was to be called *Adoration of the Magi.* The painting would portray the biblical story of Mary and the baby Jesus being visited by three magi, or wise men, bearing gifts.

Maybe Leonardo's mind was already jumping to other things. In the margin of a page with the sketches, he drew a hygrometer, a device that measures moisture in

the air. Leonardo wanted to understand the workings of practical scientific instruments and useful gadgets that had already been invented. He also found that he enjoyed thinking up inventions of his own, such as musical instruments and war machines. His fascination with inventing was beginning to distract him from his art.

In addition to these interests, Leonardo had other things on his mind while working on *Adoration of the Magi*. Throughout the year 1481, he watched with frustration as less talented artists received important commissions that he felt qualified to take on. In October Pope Sixtus IV

This *Adoration of the Magi* by Gentile da Fabriano, an earlier Italian Renaissance artist, is more ornate than Leonardo's naturalistic drawing.

asked Lorenzo to choose the finest artists in Florence to work on the famed Sistine Chapel in Rome. Artists all over the city waited in anticipation. One by one, the graduates of Verrocchio's bottega were chosen by Lorenzo to leave for Rome to work on the chapel. Leonardo, however, was not chosen. He must have been angry, frustrated, and embarrassed. He had confidence in his abilities and was tired of being ignored. Florence no longer seemed to appreciate his talent.

After working on *Adoration of the Magi* for nearly eight months, Leonardo decided to abandon it, pack his bags, and move to Milan. His exact reason for going there is unclear. He may have gone to Milan not as an artist, but as a gifted musician. He had written down many theories about and research on acoustics, the study of sound. He had even improved and invented some musical instruments during his years with Verrocchio. One of those instruments was a silver lute shaped like a horse's head. It is believed that Florence's leader, Lorenzo, may have asked Leonardo to deliver the unusual instrument to Ludovico Sforza, the duke of Milan.

But it may also have been possible that Leonardo left Florence simply out of frustration and disappointment. He had been overlooked for commissions for which he was clearly qualified, especially the Sistine Chapel. Perhaps he was feeling the need to find new areas in which to achieve success. Whatever the reason, Leonardo seemed ready to say good-bye to Florence.

4

Success in Milan

Leonardo arrived in Milan early in 1482. Surrounded by high walls and a wide moat, the city had a history of military conflict. It was crowded, polluted, and best known for the manufacture of weapons. Among its maze of crowded streets was the Street of the Armorers. There, skilled craftsmen made armor, swords, knives, and shields. Unlike Florence, Milan attracted very few well-known painters or sculptors. The city's leaders placed more value on the production of weapons than it did on fine art.

In Florence, Leonardo had worked as an artist. But he

had felt ignored and unappreciated. In Milan, he was determined to make a name for himself. He realized that his interest in inventing machines, such as weapons of war, might be useful. Hoping to gain a position in the Milanese court, he wrote a letter that he hoped would impress the duke of Milan.

"Most Illustrious Lord," Leonardo began, "I shall endeavor . . . to reveal my secrets to Your Excellency, for whom I offer to execute . . . all of the items briefly listed below." Leonardo told Ludovico that he could build bridges useful during war and knew ways to destroy any fortress, "even if it is built of rock." He claimed he had models of weapons that could hurl stones "so that they seem to be raining down, and their smoke will plunge the enemy into terror, to his great hurt and confusion."

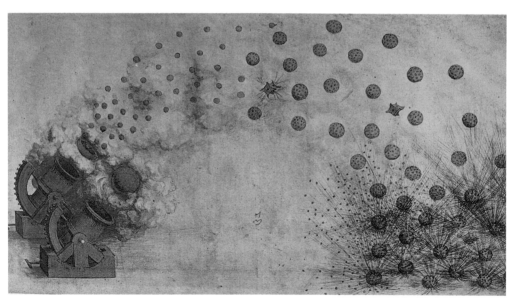

Leonardo's imagination led him to draw many military machines, such as these cannons.

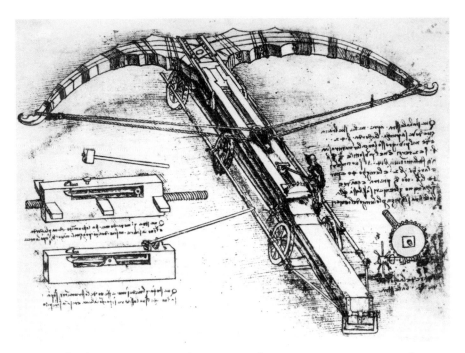

Leonardo drew this unusual weapon of war, an enormous crossbow.

He went on to write that if the battle was at sea, he had designs for vessels that could resist "the heaviest cannon fire." He boasted that he knew how to use underground tunnels and could make indestructible vehicles that would destroy troops. He said he could build catapults, flame-throwing machines, "or other unusual machines of marvelous efficiency, not in common use."

To present himself as a military engineer was a bold and boastful move. After all, his only experience with weapons or combat strategy was a disorganized collection of sketches and scribbled ideas. In fact, although weapons of destruction fascinated him, Leonardo hated war and violence. But he was willing to do whatever it took to attain a respected position in Milan.

Along with his skills as an engineer, Leonardo listed things that he could do for Milan in times of peace. He claimed to be "the equal of any man in architecture" and said he could design buildings and create machines to conduct water from place to place. Almost as an after-thought, he mentioned his artistic talents: sculpture in marble, bronze, and clay, and "in painting [I] can do any kind of work as well as any man, whoever he be."

He ended his letter to Ludovico by writing about a huge horse statue that he would be able to create. Leonardo must have heard the rumor that the duke had plans to commission an enormous bronze statue of a horse to honor his father. "The bronze horse can be made that will be to the immortal glory and eternal honor of the lord your father of blessed memory and the illustrious house of Sforza," Leonardo promised.

Leonardo may not have completed his letter to the duke of Milan. Although a draft of the letter was found among his notes, most historians believe that the letter was never actually delivered to Ludovico.

Even without the letter, word got around that a talented artist from Florence had arrived in Milan. For his first two years in the city, Leonardo supported himself by painting. By the spring of 1483, he was sharing a studio with a group of artists. On April 25, 1483, he and his new partners signed a contract with the church of San Francesco Grande in Milan. The monks of the church wanted an altarpiece for the chapel. Since Leonardo was the only one in the group with the title of master, the contract designated him, "the Florentine," to paint the

central panel. The monks specified nearly every detail of the altarpiece, from the arrangement of the figures to the color of their garments. The Virgin Mary would wear a gown of gold and blue brocade, lined with green. There were to be two prophets and angels with gold halos in the painting.

Leonardo signed the contract—and then completely disregarded it when he painted the altarpiece, later titled *Virgin of the Rocks.* Leonardo's painting had no halos, no gold brocade, and no prophets. The *Virgin of the Rocks* was nothing like the painting described by the monks. Leonardo had made it clear that he was an artist who created according to his own vision, not according to a contract.

The monks were unhappy with the altarpiece, but the small community of artists in Milan was fascinated by it. They were greatly impressed with its artistic beauty. Leonardo had an exceptional talent for using shadow, color, and perspective to create an image so solid and three-dimensional that it looked real. The faces of the figures he painted showed great expression and emotion. Word of the rebellious but talented Leonardo soon spread to Ludovico, the duke of Milan. The duke hired Leonardo to paint a portrait of his beautiful mistress. Leonardo was pleased to accept the offer and painted *Lady with an Ermine.* The duke was delighted with Leonardo's work.

Just as he had done in Florence, Leonardo found time to do more than just paint. He continued to make sketches for inventions and learn new things. He read the

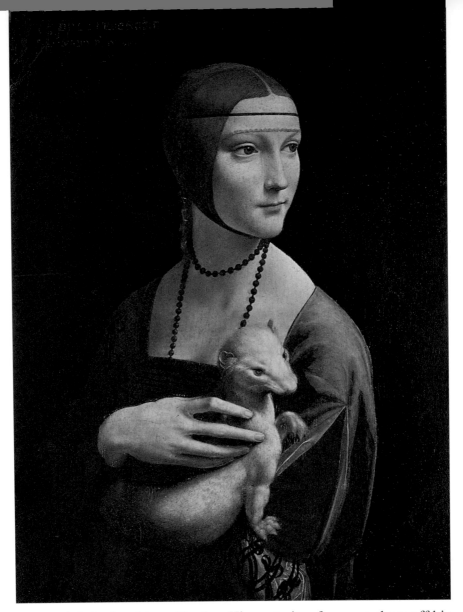

Leonardo's *Lady with an Ermine*. His portraits of women show off his ability to reflect the personalities of the people he painted.

works of scientists, geographers, historians, mathematicians, and astronomers. He wrote down interesting facts about their work. Leonardo seemed to want to know everything and to learn from everyone. It was hard to keep track of all the new ideas.

In this painting, *Virgin of the Rocks*, Leonardo uses a glowing light to create a sense of the divine.

About this time, Leonardo decided to keep more organized records of his ideas and sketches in notebooks. He filled the pages of his notebooks with theories, observations, and drawings on a variety of subjects. When one notebook was filled, he started another.

Strangely, Leonardo wrote backwards, from right to left. This writing method is called mirror writing because it reads correctly when held in front of a mirror. No one knows exactly why he wrote this way. Some experts think he was so worried about others stealing his ideas that he wanted to write in a way that would be difficult to read. Others think he wrote backwards simply because he was left-handed. Writing from right to left was easier and wouldn't smudge the ink.

Whatever the reason, the pages of Leonardo's notebooks began to multiply. He filled page after page with a hodgepodge of thoughts about everything from astronomy to his dinner menu. His mind was always racing from one idea to another. "Tuesday: bread, meat, wine, fruit, . . . salad," he wrote on the same page as notes about geometry and canals. He wrote drafts of letters to friends, lists of books he wanted to borrow, geometric formulas, and descriptions of places he visited. He jotted down recipes for paints and ideas about art. He drew people, plants, and animals. He sketched designs for war machines and military inventions, such as a device that would stop attackers from using ladders to scale walls.

Leonardo also daydreamed about ways of transporting water to various places. He made sketches of devices that would pump underground water to the surface and

machines that pumped water through a building. He also wondered if it would be possible to travel beneath the sea. In his notebooks, he drew a diver using a snorkel and a design for an aqualung for breathing underwater.

In the summer of 1484, Leonardo had a new and terrible distraction. A deadly disease, the plague, had worked its way through Europe and arrived in Milan. The disease was very contagious and caused panic in the towns and cities it struck. Some people believed the fatal disease had been sent from the heavens to punish humans for their crimes. Others thought the disease must be spreading through the smelly air and tried to protect themselves by breathing through perfumed handkerchiefs. Even medical doctors could do nothing more than recommend that the victims be isolated and that their clothes and bedding be burned after death. There was no medicine to treat the disease and no knowledge of how to keep it from spreading. Thousands of people died. Many of the survivors fled to the countryside to escape the stench and contamination from rotting corpses piled on the sidewalks and in the streets.

Leonardo was intrigued by the plague. There had to be a way to understand why it had spread so quickly. Then it occurred to him that the disease seemed to be worse in the larger towns and cities rather than in the less populated countryside. What was it about the city that caused the disease to spread so quickly? It seemed obvious to Leonardo that the waste and pollution that filled the streets of the crowded city greatly worsened the problem. What could be done, he wondered, to improve the cities

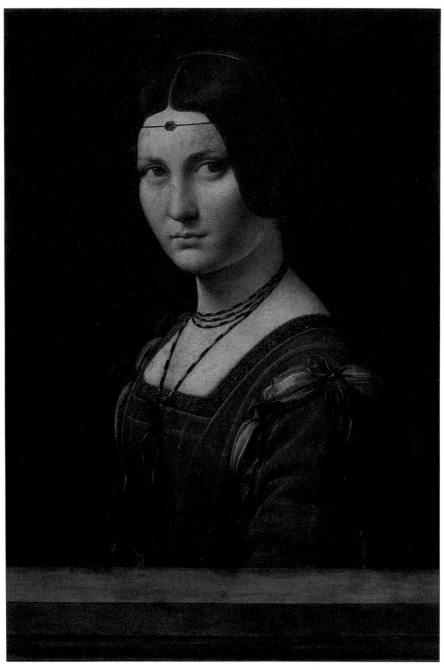

Leonardo painted this portrait, *La Belle Ferronière,* probably in 1490.

and stop the plague from continuing to kill so many peo-
ple? Breathing through a perfumed handkerchief was not
the answer.

Challenged by the problem, Leonardo set to work mak-
ing sketches of a city that would be more sanitary. His
ideal city had road systems with drainage. He designed a
street washer run by water wheels. He devised a chimney
system that would send smoke up over rooftops instead of
polluting the air below. He paid special attention to waste
disposal, sketching gutters and sewer systems.

Leonardo's ideas for a well-designed city seem to have
gone no further than the pages of his notebooks. But his
time was not wasted. He had begun a lifelong interest in
city planning and engineering. And, as usual, his active
mind was quick to make connections between different
ideas. The study of one subject led to an interest in an-
other. While sketching the streets and gutters and
rooftops of his ideal city, Leonardo became fascinated
with architecture. Along with his plans for an ideal, san-
itary city, he sketched towers, cathedrals, and spires. As
he studied the architecture around him, he began to think
more and more about how all things relate to each other.
The design of a building reminded Leonardo of the
anatomy of the human body. Many pages in his note-
books show drawings of buildings next to sketches of
legs or torsos or skulls. "Man is the model of the world,"
he wrote.

By the time the plague had ended in Milan around 1485,
Leonardo finally acquired a position in the duke's court.
His official title was engineer and painter. In January

1490, Leonardo got the chance he'd been waiting for. Ludovico was planning a feast in honor of the marriage of his nephew. He wanted the event to be extraordinary and planned to end the evening with a masque, a musical drama. The duke called on Leonardo to help him carry out his plans. Leonardo must have been delighted. Here was his chance to use his artistic and engineering talent for something more than sketches in his notebooks. He would design a masque that was lavish, extravagant, and unforgettable.

By the night of the feast, Leonardo was ready. While guests danced and sang and ate, he made sure everything was in place for the masque. At midnight, guests watched in awe as a curtain rose to reveal Leonardo's creation, *The Masque of the Planets*. In the center of an enormous revolving stage was a mountain that opened to reveal the night sky sprinkled with torch-lit stars. Surrounding the mountain were the twelve signs of the zodiac behind colored glass. Costumed actors portrayed the seven heavenly bodies that were visible in the days before the telescope: Mercury, Venus, Mars, Jupiter, Saturn, the Sun, and the Moon.

The guests at the feast were amazed. Ludovico was delighted. Leonardo was finally gaining the recognition and appreciation that had passed him by in Florence.

5

Artist and Scientist

Leonardo's years in Milan were the happiest years of his life. At the age of thirty-eight, he was a favorite of the duke and had grown so busy that he had to hire assistants. As his reputation spread, aspiring artists eagerly paid to be his student. It had been nearly twenty-six years since Leonardo had left Vinci and spent his days sweeping floors and mixing paints for Verrocchio. Now *he* was the master and teacher, and he had found the perfect match in his patron, Ludovico. Leonardo would have been unhappy if his work was only painting and sculpting. But Ludovico provided him with plenty of variety. Some days Leonardo painted portraits. Other days he taught his assistants the proper way to pour melted metal to make cannons. At the end of the day, he might sit quietly with his notebook, designing a heating system for the duchess of Milan or planning a system of canals for the city.

Charming and friendly, Leonardo had become a well-known figure in Milanese society. He was handsome and flamboyant, preferring to dress in unusually colorful and short tunics. He was said to be generous and outgoing.

Leonardo liked his busy social life and hectic work schedule, but sometimes he needed to escape. Then he would take a stroll in the countryside or along the streets of Milan. Before returning to his studio, he would often stop to sketch the face of a street merchant or to shop at the marketplace. Sometimes he would buy caged birds so that he could set them free. Despite his interest in war machines and weapons, he was a gentle and compassionate man who loved animals. That was probably the reason he became a vegetarian.

The energetic and ever curious Leonardo never wasted a single minute. Everything he saw, heard, or experienced was an opportunity to learn something new. Hardly a day went by that he didn't find something to study, to experiment with, or just to wonder about.

Leonardo was certain that the five senses were the keys to learning more about the world around him. Of all the senses, he believed that sight was the most noble. About the same time that he was building his career in Milan, he began an intense study of optics, the science of light and vision. Through his observations and experiments as an artist, he had a basic understanding of the nature of light and shade. He also knew how primary colors combine with each other to make different colors. But he wanted to explore optics more scientifically. He began to develop his own theories of vision, to construct optical devices, and to conduct an in-depth study of the human eye.

Leonardo found human eyes from medical schools and hospitals. He planned to dissect them, or cut them apart. He wanted to peel back each layer of the human eye and

study every part. But cutting neatly through an eye proved difficult. How could he slice open the jellylike glob of an eye? After some experimenting, he came up with a way. First he immersed the eye in egg white. Then he boiled the egg-coated eye. This process hardened the eye and created a firmer surface to cut through. Layer by layer, Leonardo sliced open the eye, examining, sketching, and making notes. He devoted one notebook to this single subject, optics, rather than randomly jotting down notes on a variety of ideas.

Through experiments, Leonardo began to develop his own theories about sight. His ideas were quite different from most of the accepted theories of the time. Many scientists thought humans had vision because of tiny particles projected from the eye. But Leonardo's experiments led him to the correct conclusion that vision is a result of the eye receiving rays of light. His dissections of the eye revealed that one of the most important parts of the eye is the lens. But how does the lens work? he wondered. His studies of the lens led him to theories about what causes far-sightedness, which he may have suffered from.

Hour after hour, Leonardo pored over his notes and drawings. He tried to make glass instruments that could work like the eye and may have even designed one of the earliest contact lenses. Experimenting with the workings of the eye led him further into studies of light. Did light really appear instantly, as most scientists believed, or did it travel? Leonardo believed that light did, indeed, travel. But how fast, he wondered. In his notebooks, he may have tried to calculate the speed of light. He also seemed

to understand that light moves as a wave and that there is a connection between the movement of light and sound. These ideas were centuries ahead of their time.

Even though Leonardo was devoting more and more time to scientific studies, he still found time for art. Since arriving in Milan, he had not abandoned his dream of creating the huge bronze statue of a horse and rider that Ludovico wanted. Like other artists throughout Italy, Leonardo had ideas for the design of the horse. But he knew that to mold and cast such an enormous statue would be a difficult challenge. During his years in Milan, he had been studying the bodies of horses. He had also been experimenting with designs and learning about bronze-casting techniques. He had wanted to be ready if Ludovico decided to hire him for the job.

He must have been pleased when he finally learned that he had been chosen to create the statue. With renewed energy, he enthusiastically prepared for the project. He visited stables to study horses, sketching their manes, their muscles, their heads. He drew horses running, horses rearing, horses prancing. Typical of Leonardo, studying one subject gave him ideas about a related subject. While observing horses, he got ideas for improving stables and keeping them cleaner.

By the summer of 1490, Leonardo had settled into a contented routine of work and study. Then, a mischievous young boy entered his life and brought with him a bit of turmoil.

In his notebook of theories about optics, Leonardo wrote, "Giacomo came to live with me on the feast of

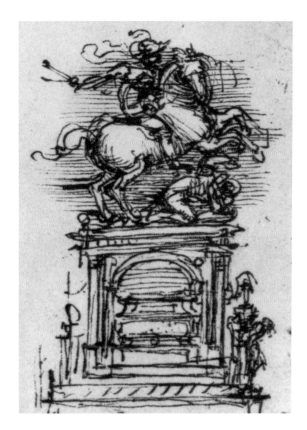

One of the many sketches Leonardo drew for the bronze horse statue he planned to create for Ludovico

Saint Mary Magdalena [July 22] of the year 1490. He is ten years old." It is not certain exactly why Leonardo took the boy in. Giacomo may have been an assistant or pupil of Leonardo's. Leonardo himself, in drafts of letters, sometimes referred to the boy as "my pupil." But the few paintings known to have been painted by Giacomo are of poor quality and suggest that he had little artistic talent. Most experts agree that Giacomo was probably a peasant taken into Leonardo's home as a servant, or possibly as a model.

What is certain is that Giacomo was a rascal from the start. On his second day in the workshop, Leonardo had

some new clothes made for the boy. "But when I put aside the money to pay for them," Leonardo wrote, "he stole this money from the purse. Although I have not been able to get him to admit it, I am absolutely sure that he did. The day after, I went to sup with Giacomo and the said Giacomo supped for two and did mischief for four, for he broke three cruets and spilled the wine." Leonardo then added in the margin, "Thief, liar, obstinate, greedy."

It is not surprising, then, that Leonardo nicknamed the boy Salai, Italian for "little demon." Leonardo's notebooks contain page after page of complaints about Salai, naming the items he stole and recalling his poor behavior in front of guests. He also kept lists of mounting expenses due to the mischievous boy.

Despite Salai's bad behavior, Leonardo must have been fond of him. Perhaps he was amused by Salai and saw a bit of his own rebellious spirit in the naughty child. Some days he spoiled the boy, lavishing him with gifts and dressing him in fine clothes. Other days he was angry and irritated at the child. Over time, the two grew close.

By November of 1493, Leonardo was finally ready to present Ludovico with a full-size clay model of his horse statue. Everyone who saw it was amazed. The horse alone was over twenty feet high, as tall as a building! Not only was the statue gigantic, but it was magnificently sculpted.

Once the clay model was completed, Leonardo faced the difficult task of actually casting his statue in bronze. The statues he had learned to cast from Verrocchio had

been far smaller than the enormous horse. He knew he needed to move the clay model so that he could prepare a mold. But how? Leonardo sketched and planned and studied until he came up with a design for a huge engine that he could use to move the clay horse. Once the horse was moved, however, Leonardo would have to know how much bronze he would need for the statue. Leonardo measured and added and multiplied and measured some more. To make sure his figures were accurate, he asked some of his mathematician friends for help. He calculated that he would need nearly seventy tons of bronze! How would he ever melt that much bronze and then pour it into the mold before it began to harden and crack? Once again, Leonardo sat down with his notebooks to figure and sketch. He came up with a plan to use four furnaces to melt the bronze.

By early 1494, Leonardo was ready to begin turning his beautiful clay horse into a fantastic bronze statue. Unfortunately, Italian politics interfered with Leonardo's work. With rivalries flaring between ruling Italian families and trouble brewing with France, Milan found itself on the verge of war. All of the bronze that Leonardo had planned to use for his statue was needed for casting cannons, swords, and other weapons.

Although there is no record of Leonardo's reaction to this turn of events, it is not hard to imagine that he was bitterly disappointed. After all of his years of work and study, his magnificent horse would never be more than a clay model. Nevertheless, Leonardo's fame as a sculptor had begun to spread throughout Italy.

6

Inventor

About the time that Leonardo was preparing his clay horse model, a woman named Caterina came to live with him. Was this woman Leonardo's mother? Or was she, perhaps, merely a servant? No one knows for sure, but some historians believe that she was, indeed, his mother. Aside from his notes about Salai, it was unusual for Leonardo to write comments about his personal life in his notebooks. It was also unusual for him to date his entries. Yet on one page he wrote, "Caterina came, 16 July 1493." The arrival of this Caterina seems to have been significant.

From time to time over the next two years, Leonardo made notes about money that he spent on her. "For Caterina," he would note in a list of expenses. Caterina stayed with him until she died in 1495. Leonardo made one

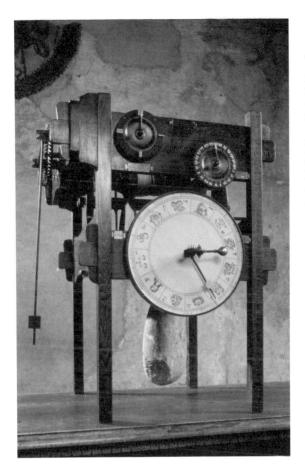

This clock, made in modern times, is based on a sketch that Leonardo left behind. Leonardo rarely transformed his ideas into actual inventions. But many of them have proven to work successfully.

more list, "Expenses of Caterina's burial." The amount of money that he spent on her burial suggests that this Caterina was more than just a servant.

Leonardo could afford to provide a nice funeral for Caterina. Ludovico paid him well for his work. Although he stayed busy working for Ludovico and managing his growing workshop, Leonardo continued to fill up his notebooks with new ideas. Even while reading, he kept his notebook and pen handy. He often jotted down the names of books and authors, copying long passages

that interested him, or making vocabulary lists. One notebook contained more than nine thousand vocabulary words! But keeping his notes organized was impossible for Leonardo. Everything fascinated him. He wanted to know so much. Almost everything he saw made him think of a question. How does it work? What is that for? What causes this to happen? Where does that come from? So many questions. So much to learn. Leonardo wasn't willing to accept the theories passed down by others. He wanted to find the answers himself.

His studies about light and how it traveled had made Leonardo think more and more about movement. Thinking about movement made him think about machines. Thinking about machines made him think about how a human body in motion is similar to a machine. Joints were like hinges, he noted. Muscles and bones were like gears and levers. "Motion is the principle of all life," he wrote. On and on went Leonardo's thoughts, one thing always leading to another.

Leonardo also continued to delight in inventing or improving many kinds of machines. He especially loved the idea of machines that could operate on their own. How could a door open without a person pushing it? How could a vehicle move without a horse pulling it? Could a drum make a sound without a person beating it?

Such questions led him to sketch designs of some of the ideas he had been thinking of. He drew a set of doors that opened and closed automatically by using ropes and weights. He figured out a way to make sticks pound on a military drum as the drum moved along beside the troops

marching into battle. He designed a military tank that could move on its own with a spring-powered motor. He even designed a kind of steam engine that would power an automobile. Leonardo drew his inventions from every angle, inside and out. His studies were far ahead of any other mechanical engineer of his century.

One of the inventions Leonardo became most obsessed with in the 1490s was a machine that would allow humans to fly. For some time, Leonardo had been studying in great detail the bodies of birds and observing how they fly. He wrote detailed notes about what he saw. He was able to explain how birds remain in the air and how they use their wings and bodies in flight. He studied the relationship between the size of a bird's wings and the weight of its body. He dissected a variety of birds to study the construction of their wings. Leonardo's work in the area of flight is an example of his unique ability to combine his extraordinary talent as an artist with his thorough scientific observations. His study of the flight of birds was to become one of his greatest contributions to science.

Leonardo's fascination with flight led him to thinking about how a human might be able to fly. As usual, fascination turned to obsession. He wondered if he could recreate the flight of a bird with a machine that could carry a person. Maybe he could design a device with moveable wings, he thought. But how would those wings be made to flap like a giant bird? How large should the wings be? What material would be the lightest and strongest? Should the pilot sit or lie or stand while flying?

Leonardo was determined to invent a flying machine,

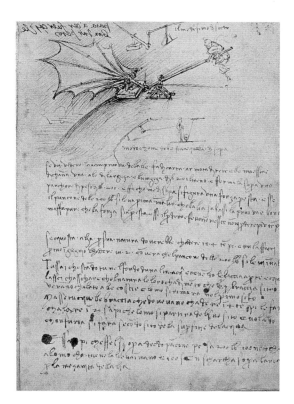

This page from Leonardo's notebooks shows one of his many ideas for a flying machine.

which he called a ship of the air. He experimented with a variety of ideas and sketched drawings of his designs. Although Leonardo was not the first person to design devices intended for human flight, many of his ideas were new. One of his designs was a contraption with four wings. A man would get inside and fly by turning cranks and pushing pedals that worked the wings. Another of his designs was called an aerial screw and resembled the modern-day helicopter. He wrote himself careful instructions for testing out one of these machines. "You will experiment with this machine over a lake," he instructed himself, "and you will wear attached to your belt a long wineskin, so that if you fall in, you will not be drowned."

He wanted to make sure he would be safe in case the machine failed.

It is unlikely that Leonardo ever actually attempted to fly or even build a life-size model of any of his devices. But his experiments and small-scale models led to other useful ideas related to flight, such as a parachute and safety devices for landing on water.

Although he spent much of his time with his scientific studies, Leonardo had not abandoned art. About 1495, he began what was to become one of his most well-known paintings, *The Last Supper.* Commissioned by Ludovico, the painting was to be a fresco, a painting done on moist

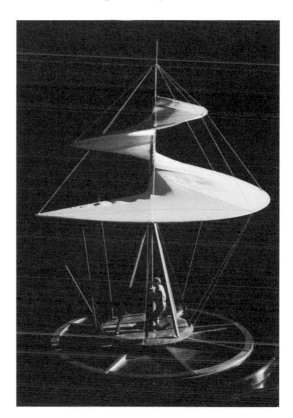

This model of a screw-shaped flying machine is based on drawings that Leonardo made.

plaster. It was to be done on a wall in the dining hall of
Santa Maria delle Grazie, a monastery in Milan. *The
Last Supper* would illustrate Jesus' last meal, which he
shared with his disciples the night before he died. The
scene was a common religious one often used to decorate
monasteries. Leonardo was glad for the chance to paint
the mural, but he didn't want his painting to be like others
of the same subject. Most paintings of Jesus' last meal
simply illustrated the scene of the disciples sharing bread
and wine with Jesus. The paintings revealed little action
or emotion.

Leonardo decided his painting would depict the very
moment that Jesus tells his devoted followers that one of

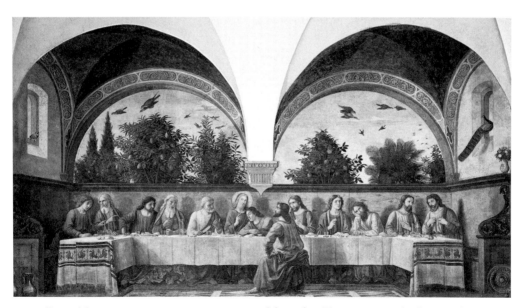

Jesus' last supper was a common subject for European paintings. Like
many of the paintings of this scene that came before Leonardo's, this
one, painted by Domenico Ghirlandaio in 1480, shows Jesus and the
disciples calmly sitting in a row, with Judas, the betrayer, set off from
the rest.

them will betray him. Through his art, Leonardo planned to show how each disciple reacted to Jesus' shocking words. That way, the personality of each individual would come through.

First, Leonardo needed to design the overall arrangement of the scene. As always, he spent months studying, sketching, and planning before starting the painting. Combining his knowledge of geometry and perspective, he designed the scene so that it would appear to be part of the monastery's dining hall. His painting would create the illusion that the hall itself extended right into the image of Jesus and the disciples at the table. To add to the realistic appearance of the scene, he even would paint the table, dishes, glassware, and tablecloth exactly the same as the ones used by the monks.

Next, he concentrated on each of the figures in the painting. Leonardo believed that gestures and facial expressions could reveal a lot about human character and emotion. He spent hours walking the streets of Milan, searching for people who resembled his vision of the disciples. He studied their faces and observed their body movements. Then he carefully composed his sketches so that each disciple revealed his reaction to Jesus' prediction of betrayal. He wrote the names of each disciple in his notes, then decided what each would be doing and what emotion he would be expressing. "One who has just been drinking has put down his glass and turned toward another, who is speaking," he wrote. "Another displays the palms of his hands and shrugs his shoulders up toward his ears, struck dumb with amazement." Leonardo wanted

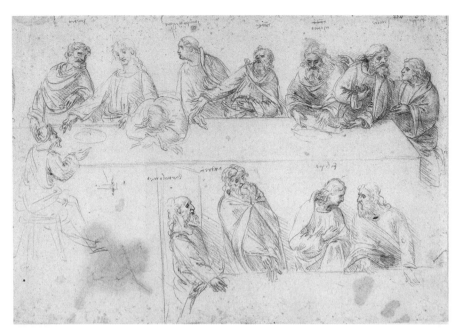

Leonardo drew this sketch in preparation for *The Last Supper*. He carefully thought out the placement and expression of each figure.

his painting to show the individual feelings of each of the disciples. Which one was afraid? Which one was angry? Which one was surprised? Leonardo would make his version of *The Last Supper* more than just thirteen people sitting at a table. His painting would tell a story.

When he was finally ready to begin the painting, Leonardo decided to try something new. The usual method of fresco painting is for the artist to apply wet plaster to the wall, then quickly paint the scene before the plaster dries. But Leonardo had never worked quickly and had no intentions of doing so now. He decided to experiment. He wanted to find a way to paint his fresco more slowly and then be able to go back and make changes if he needed to. He developed his own materials

to apply to the wall. He hoped this new surface would allow him to work more slowly.

Day after day, Leonardo came to the monastery to paint. The dining hall was often crowded with people eager to watch him work on the thirty-foot-wide mural. One onlooker described Leonardo's work habits. "He sometimes stayed there from dawn to sundown, never putting down his brush, forgetting to eat and drink, painting without pause. He would also remain two, three, or four days without touching his brush, although he spent several hours or days standing in front of his work, arms folded, examining and criticizing the figures."

Complaints from the monks about his slow pace didn't seem to affect Leonardo. He spent two years painting *The Last Supper.* When it was completed, the people of Milan were thrilled by the fresco. They saw that indeed it was a masterpiece. Unfortunately, Leonardo's experimental fresco method was a failure. Not long after completion, the paint began to flake off, eventually leaving the beautiful mural nearly in ruins.

The following year, in 1498, Milan once again found itself facing the possibility of war. The king of France, Louis XII, had gathered troops to invade the city. By the fall of 1499, Ludovico had fled Milan and Louis XII had taken control. Leonardo had lost his patron but quickly learned that the French ruler valued his talents and was eager to hire him.

At first, Leonardo considered working for Louis. When the French began looting and murdering throughout the city, however, Leonardo thought he might have to leave.

Leonardo's *The Last Supper* is remarkable for its innovative composition and sense of immediacy. Leonardo made his scene dynamic by showing the disciples interacting with each other. Judas *(fourth from left)* is leaning against the table looking at Jesus.

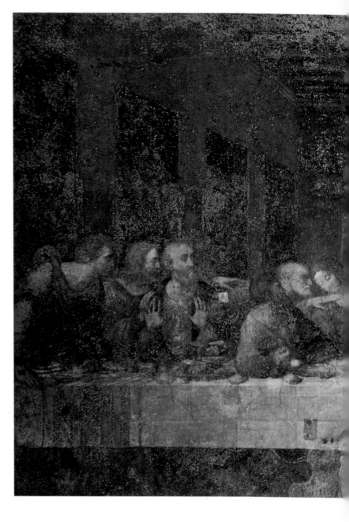

He made notes to himself about what to pack, what to sell, and what to buy before he left. Yet despite the destruction going on around him, and with hundreds of others leaving Milan, Leonardo hoped that he would be able to stay. He had lived in Milan for nearly eighteen years. He owned land given to him by Ludovico, and he knew he could find work with the new French government if he stayed on in the city.

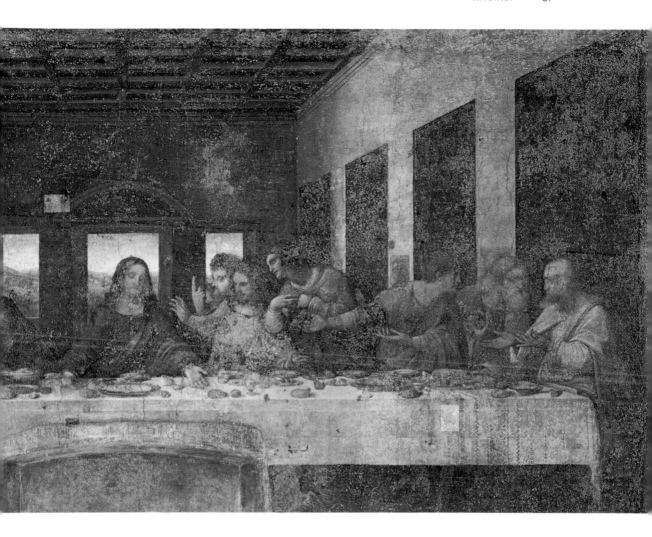

Then one morning, French archers decided they needed to practice their aim by shooting arrows at a target. They chose Leonardo's magnificent clay horse for their target practice. Leonardo watched in horror as the arrows mutilated the giant statue he had worked on for so many years. Any reluctance he may have had about leaving Milan disappeared. Leonardo gathered his belongings and left Milan with Salai.

7

Battles

After leaving Milan, Leonardo wanted more time to devote to his scientific studies. But he had to support himself. He would have to take whatever work came his way.

Leonardo settled briefly in Mantua, about eighty miles from Milan, and did some painting. From there, he moved on to Venice, a city surrounded by water. Venice was facing the possibility of military attack by its enemies. Leonardo worked on several designs to help Venice defend itself. His designs included a movable wooden dam and a submarine.

He also developed a plan for a group of underwater divers to sneak up on an enemy boat from underneath and pierce the body of the boat with drills. The divers would wear glass goggles and breathe through wineskins full of air. He wrote down every detail about how the divers' suits should be designed. He even offered suggestions for how the suits could be made. "Get a simple-minded fellow to do the job," he wrote, "and have him sew the suit

up for you at home." Leonardo's ideas were interesting and unique, but they were never put into practice.

Sometime in 1500, Leonardo left Venice. By the end of April 1500, he was back in Florence. His seventy-four-year-old father, Ser Piero, still lived there. Leonardo had not seen his father during the years since leaving Florence, although he may have stayed in touch by letter. One of his notebooks contains a draft of a letter to his "dearly beloved father." After arriving in Florence, Leonardo probably visited Ser Piero, who lived with his fourth wife and eleven children.

Leonardo had been a young man when his father saw him last. Now forty-eight years old, Leonardo was considered quite old. He had left Florence as a promising young artist with a future ahead of him. He was returning to Florence some eighteen years later as one of the most famous artists in Italy and possibly all of Europe. But besides his reputation as an artist, Leonardo had another reputation that followed him to Florence. He couldn't seem to finish many of the projects that he started. Sometimes he just didn't think a painting was good enough and would simply abandon it. Other times he was too preoccupied with his scientific studies to be bothered with finishing, or even starting, a promised painting. More and more, he assigned a painting to his students and merely added a hasty brush stroke here and there.

Still, art patrons of Florence sought him out. They were anxious to own a piece of work by the famed Leonardo da Vinci. One patron, Isabella d'Este, was determined to hire him. A relative of Ludovico, she was noted for her beauty,

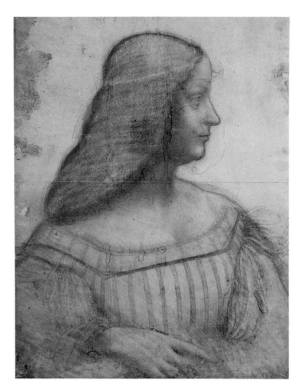

Leonardo's unfinished *Portrait of Isabella d'Este*

wealth, and arrogance. Isabella was also a well-known collector of fine art. She paid generously for the art she commissioned but usually demanded that the artist paint exactly what she wanted. She had been trying for a number of years to convince Leonardo to finish a portrait of her that he had started but never finished. If she couldn't have her finished portrait, she was determined to have *something* painted by the famous artist.

When Isabella learned that Leonardo was back in Florence, she continued to push him to paint for her. She wrote letters to him. She wrote letters to his friends and relatives. She offered him large sums of money. She flattered and praised him. But Leonardo was not interested.

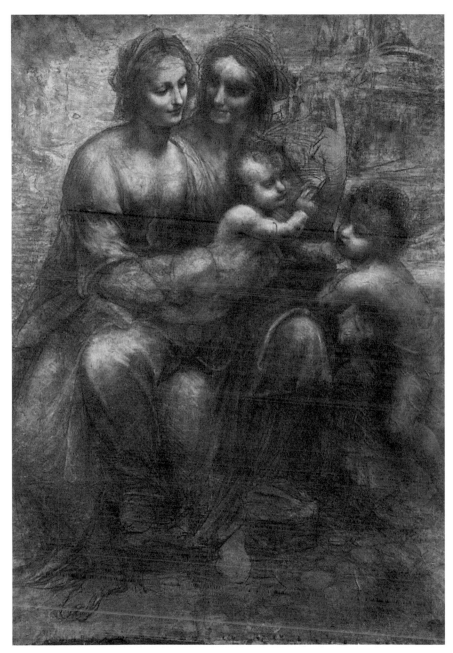

Leonardo probably created this cartoon, *The Virgin and Child with Saint Anne,* in the early 1500s. Years later he completed a painting with the same title but with a slightly different composition.

While other great Italian artists, such as Bellini, Titian, and Raphael, painted for the demanding woman, Leonardo doesn't seem to have replied to her pleas. He never had been, and never would be, an artist who could be told what to do.

In the spring of 1502, Leonardo was offered the position he had dreamed of since leaving Florence more than twenty years earlier: military engineer. The offer came from Cesare Borgia, a ruthless and powerful military man who dreamed of conquering all of Italy.

For the next six months, Leonardo traveled with Cesare from city to city. He inspected fortifications and made suggestions about how to improve them. He kept a special notebook to record his designs of weapons and war devices. Before long, the pages were filled with his unusual ideas, such as secret escape tunnels and movable bridges. He shared these ideas with his new patron.

Leonardo found his work for Cesare interesting and satisfying. His gentle nature and distaste for war, however, made it more and more difficult for him to work for a bloodthirsty man with a brutal army. By March 1503, Leonardo had quit his job and returned to Florence.

Right away, he received offers for work as both an artist and a military engineer. That fall, he was commissioned to paint an enormous mural on one of the walls in the government meeting hall, the Piazza della Signoria. The painting was to depict the Battle of Anghiari, a great Florentine victory over Milan sixty years earlier.

Leonardo already had an idea of how he would compose the painting. For years, he had been making notes

to describe his vision of a battle scene. "A horse will be dragging behind it the body of its dead rider," he wrote. "Have all kinds of weapons lying underfoot. . . . You could show a warrior disarmed and knocked to the ground. . . . Or a pile of men lying on the corpse of a horse. . . . Take care not to leave a single flat area that is not trampled and saturated with blood."

Leonardo's first sketches of *Battle of Anghiari* closely matched the descriptions in his notebook. In February 1504, he planned ahead by ordering materials to build a scaffold. Leonardo would climb on this wooden platform to reach the top of the large painting. Soon afterward, Leonardo got some disappointing news. Another battle scene was going to be painted on the wall opposite his scene. The artist who would paint it was Michelangelo di Lodovico Buonarroti, Florence's most beloved artist. Michelangelo was only twenty-nine years old, but already he was one of the greatest sculptors of the century. One of his most famous sculptures was his magnificent statue *David*. Michelangelo was Leonardo's greatest rival. The two men respected one another's work but were jealous and competitive. They had even been seen arguing in public. Leonardo was not happy about the prospect of working day after day in the same room with Michelangelo.

The people of Florence, however, were fascinated by the rivalry between the two artists. Curious onlookers crowded into the Council Chambers to watch what was called "the Battle of Battles."

Leonardo and Michelangelo finished the sketches of

their battle scenes about the same time, near the end of 1504. Other artists in Florence were excited about the project and looked forward to seeing the finished paintings by the two great artists. Unfortunately, that would never happen. Neither Leonardo nor Michelangelo completed his battle scene.

Leonardo had problems with his painting from the first day. A vessel holding water broke nearby, splashing water onto the paper cartoon of his scene. The drawing began to come apart. Things continued to go badly. Some historians believe that the plaster on the wall was in bad condition. Others think that Leonardo may have used poor quality oil to make his paints, or that he may have used a paint recipe that wasn't right for the project.

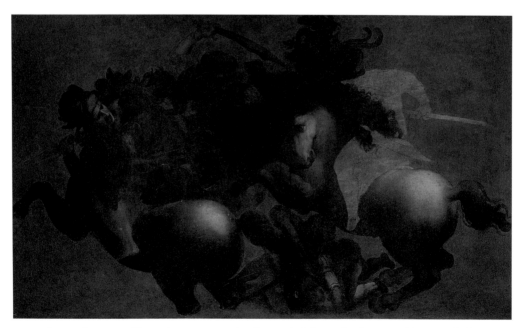

An unknown Renaissance artist based this painting on Leonardo's unfinished *Battle of Anghiari.*

Michelangelo's paintings on the ceiling of the Sistine Chapel are considered one of the greatest accomplishments of the Renaissance.

Whatever the case, when Leonardo tried to dry the painting with the heat from a charcoal fire, the colors began to run, leaving a mess instead of a mural. In May of 1506, when King Louis XII of France requested that Leonardo return to Milan, the frustrated artist abandoned his unfinished painting and left Florence. About the same time, Michelangelo left Milan for Rome. He had been summoned by the pope to begin painting the ceiling of the Sistine Chapel.

The Battle of Battles was over.

8

The Merry One

In the spring of 1508, fifty-four-year-old Leonardo decided to organize his collection of notebooks. After nearly twenty-five years of making notes and drawing sketches, he had filled thousands of pages with a jumble of subjects.

The task of organizing his vast collection of notes was a daunting one. Most of the subjects were unorganized and undated. How could he ever manage to put them in order? Leonardo realized that the best way to begin was to concentrate on only a few subjects at a time. He chose the ones he was most passionate about: water, painting, optics, and the human body. Still, the job of sorting his notes was slow and tedious.

About the same time that Leonardo was trying to organize his notebooks, he grew obsessed with human anatomy, the study of the human body. Nearly twenty

years earlier, he had begun to study anatomy as an artist, to help him draw more realistically. As time went on, however, he had become intrigued with how the body worked, not just how it looked. How did muscles work? What caused blood to flow? Did nerves affect the senses? Leonardo's questions seemed endless, and he was determined to find the answers. There was almost no information available in books. What little there was came mostly from ancient theories passed down for hundreds of years.

To find out for himself how the human body worked, Leonardo bravely dissected cadavers, or dead bodies. Human dissections weren't common in those days, and it was often difficult to get an entire cadaver. Instead, Leonardo was often only able to dissect body parts, such as legs and arms.

He sliced open abdomens, peeled away tissues, removed organs, and sawed through bones. He opened skulls and cut limbs in half so he could see inside them. There were no chemicals to preserve the bodies, so the cadaver Leonardo was dissecting often began to rot before he could finish. In his notes, he warned that it was not very pleasant "passing the night hours in the company of these corpses, quartered and flayed and horrible to behold." Leonardo's fascination with his work, however, helped him overlook the unpleasantness of probing the rotting innards of a foul smelling cadaver.

For Leonardo, the best way to record the details of what he saw was by drawing. The few illustrations that could be found in medical texts in those days were basic

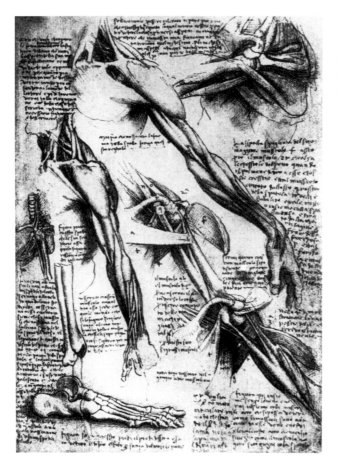

A page of anatomical
drawings from
Leonardo's notebook

and crude. They revealed little about the inner parts of
the body. Leonardo's drawings were like nothing that
had ever been done before. He drew the outside of or-
gans, sliced them open, and then drew the insides. He
drew limbs from every angle: top, bottom, and sides.
Then he cut them in half and drew cross sections. He
sketched with precise detail the layers of tissue, bone, and
muscle. He drew the nervous system, the digestive sys-
tem, and the circulatory system. He even drew the intri-
cate folds of gray matter inside a human brain.

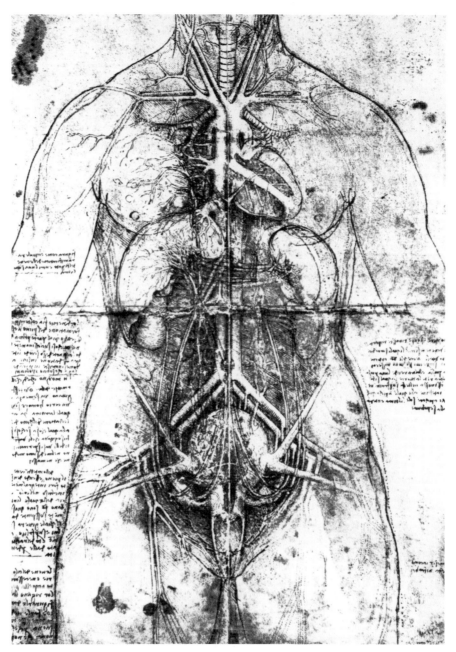

In his lifetime, Leonardo produced more than 1,500 detailed drawings of the human body. His study of anatomy is considered one of his greatest achievements as both an artist and a scientist.

Again and again throughout his notebooks, Leonardo compared the human body to a machine. Alongside a sketch of muscles and organs, he might draw levers and gears. As an inventor, he understood how difficult it was to create a perfectly working machine. The more he learned about anatomy, the more appreciation he had for what he called the human machine.

At the same time that Leonardo busily worked on various scientific research, he also ran his workshop. Young men continued to enter the bottega in order to learn from the master artist. Around 1507 Leonardo had taken a young artist by the name of Francesco Melzi under his wing. Francesco was the seventeen-year-old son of wealthy parents. He had convinced his parents to allow him to join Leonardo's workshop to pursue a career in art. Unlike Salai, Francesco was not only well educated and well bred but was also a talented artist. Leonardo and Francesco liked each other from the start. The younger artist admired and respected Leonardo's work. Leonardo saw much promise in his new friend and encouraged him.

Now Leonardo spent most of his time organizing his notes, teaching his pupils, and doing a variety of jobs for the Milanese court. He also continued his studies, especially in the area of anatomy. Somehow, he still found time to paint. In the early 1500s, Leonardo completed at least four paintings: *Saint John the Baptist, Leda, Virgin and Child with Saint Anne,* and the *Mona Lisa.*

In Leonardo's most famous portrait, the *Mona Lisa,* a woman sits with hands folded. Although she wears a dark gown and veil, as if in mourning, she is smiling.

The landscape behind her is misty and almost dreamlike, with Leonardo's characteristic rocks and water. The sky is beginning to darken. Because of the woman's famous smile, the portrait is called *La Gioconda,* "the merry one" in Italian.

The *Mona Lisa* was extraordinary for its time. To those people who viewed Leonardo's masterpiece, the woman looked as if she could come right out of the painting. And, just like a real person, she seemed to have her own private thoughts. It's hard to tell exactly what she is thinking and feeling. Was she happy, cunning, or perhaps distant and sad? Everyone who looked at the painting had a different opinion.

Leonardo created this mysterious, lifelike portrait by using his new technique called *sfumato.* This Italian word means "smoky" or "hazy." Unlike many other artists of his day, Leonardo avoided using harsh outlines for his figures. Instead, the edges of the woman and the details of her face, hands, and clothing have soft outlines. These edges blend into the shadows or light that surround them. In addition to a careful use of shading and color, Leonardo was very particular about the position of the woman. Her body is turned slightly and her hands rest gently on her arms. Leonardo wanted to paint the woman in a natural pose rather than one that would seem stiff or rigid.

The *Mona Lisa* is not only one of Leonardo's most well-known paintings, it is one of the most recognizable paintings in the history of art. The portrait is also one of the art world's biggest mysteries. Who was this woman with a hint of a smile on her face?

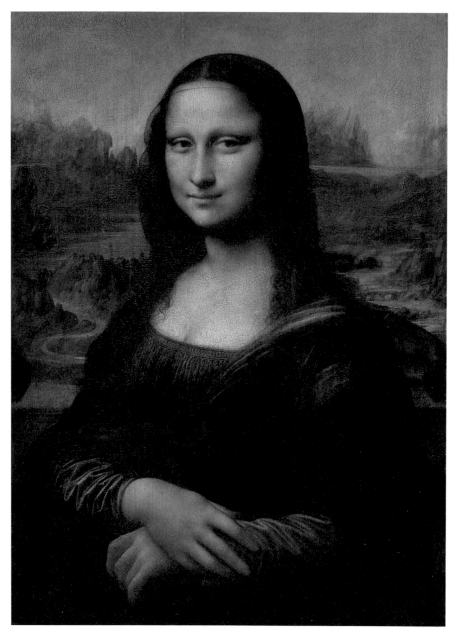

Leonardo's mysterious *Mona Lisa.* Biographer Vasari claimed that Leonardo hired musicians and clowns to keep a slight smile on the woman's face while he painted her. Historians have never been able to prove the truth of this story.

Many experts have proposed theories about the identity of Mona Lisa. Was she an Italian duchess? Perhaps she was the wife of a friend. Some have suggested that she may have been the demanding Isabella d'Este. Maybe she wasn't a real woman at all, but a creation of Leonardo's imagination. There have even been suggestions that the *Mona Lisa* is a self-portrait of Leonardo himself!

Historians also disagree about when Leonardo painted the *Mona Lisa*. Some believe he painted it in Florence,

Leonardo's finished painting *Virgin and Child with Saint Anne*

Leonardo made this sketch for his painting *Leda*. His final painting was lost, but it inspired many similar paintings.

before he returned to Milan in 1506. Others claim he may have begun the painting in Florence but completed it in Milan some years later.

Besides wondering who Mona Lisa was and when Leonardo painted her, art historians also wonder why Leonardo painted the merry one. Was the portrait commissioned? If it was, who commissioned it? Unlike his other works, Leonardo kept the painting. Why was it never delivered to the person who commissioned it? These questions remain unanswered. In all of the thousands of pages of Leonardo's notebooks, there is not a single reference to the *Mona Lisa*.

Late in 1511, Leonardo's life was disrupted again. Once more, political upheaval struck Milan.

Venice and Rome drove the French out of the city and put a new ruler on the throne in Milan. Leonardo left the city to stay with the family of his pupil and friend Francesco Melzi. Francesco's family lived in the countryside outside of Milan. Leonardo spent at least a year there with Francesco, Salai, and his other pupils. The fifty-nine-year-old artist enjoyed the peace and serenity of the countryside and must have cherished the time he had to devote to his studies. But eventually, Leonardo was called away from his peaceful retreat.

Late in the summer of 1513, Giuliano de' Medici, the pope's brother, invited Leonardo to come to Rome. The city was growing, and there was new demand for paintings and sculpture. Giuliano was an admirer of Leonardo's and a well-respected patron of the arts. Perhaps, he told Leonardo, the patrons of Rome would be interested in commissioning work from the esteemed artist.

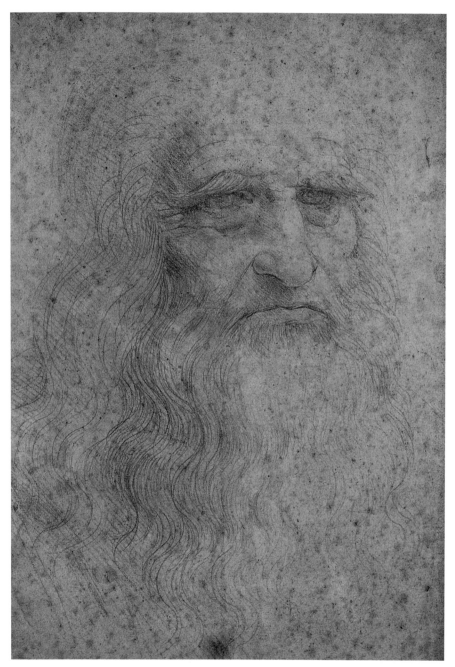
This is the only self-portrait we have of Leonardo. He probably drew it when he was fifty-five years old.

9

France

After arriving in Rome near the end of 1513, Leonardo settled into an elegant suite of rooms offered to him by Giuliano. He looked forward to receiving new commissions from the city's wealthy patrons. It didn't take long, however, for him to realize that he was no longer in touch with the art trends of the day. At the age of sixty-one, Leonardo da Vinci was out of style. He had also maintained his reputation for being slow and unreliable. The wealthy patrons of Rome were hiring younger, more fashionable artists who could be counted on to do their work on time. To Leonardo's frustration, he once again found

himself sitting idly while others received the commissions he felt he deserved. His notebooks hint that he may also have been in poor health. Scattered occasionally throughout his notes are references to doctors and illness. Some historians believe he may have suffered a stroke. His eyesight seems to have declined, as well. It is not hard to imagine why these were unhappy times for Leonardo.

With little else to do, Leonardo immersed himself in his studies. As was his habit, he studied many subjects at once. One day he studied motion, the next plants or geometry or anatomy. He also worked on inventions, such as a machine to make rope and another to mint coins.

As the months went by, Leonardo seemed to grow increasingly unhappy. He was often moody and irritable. He began to fill his notebooks with dark and brooding thoughts. He wrote detailed descriptions of his vision of the end of the world. He had always had a fascination with water and seemed to have had a morbid fear of floods. In his notes from around 1514, he described in great detail a terrible flood, referred to as the Deluge. He then drew a series of ink sketches of the Deluge, showing the destructive waves washing away towns and whole mountains.

But the following year, 1515, just as Leonardo seemed to be slipping deeper into a dark depression, something happened that perked him up again. King Francis I of France took the throne and began a campaign to control parts of Italy. The pope, Leo X, hoped to make peace with the new king and keep the French out of Rome.

When the pope organized peace talks with King Francis, his brother Giuliano called on Leonardo for help. Leonardo's new patron asked him to create something special that would make an impression on the French king. Giuliano wanted something that would represent a union between the Italian states and France.

Leonardo didn't disappoint his patron. He designed a fantastic mechanical lion, which symbolized the lion of the Medici family. With the help of wound springs and wires, the lion walked by itself. After a few steps, the creature's chest fell open. Inside, where the lion's heart would have been, was a fleur-de-lis, or lily. The lily was the symbol of the French king.

It seems likely that Leonardo attended the peace talks with his walking lion and may have met King Francis there. The king had admired Leonardo's work for some time. When Giuliano died the following year, Francis invited Leonardo to come to France as a member of his court.

Leonardo had few happy memories of his time in Rome. He must have been glad for the opportunity to leave. He packed his manuscripts, drawings, and paintings (including the *Mona Lisa*) and left Rome with Salai, Francesco Melzi, and a servant.

If Leonardo had felt unappreciated and out of fashion in Rome, he probably felt the opposite way in France. Francis I was not yet twenty years old but was known as a man who loved all forms of art, from paintings to poetry to music. In addition to paying Leonardo a generous income, the king also provided him with a manor house

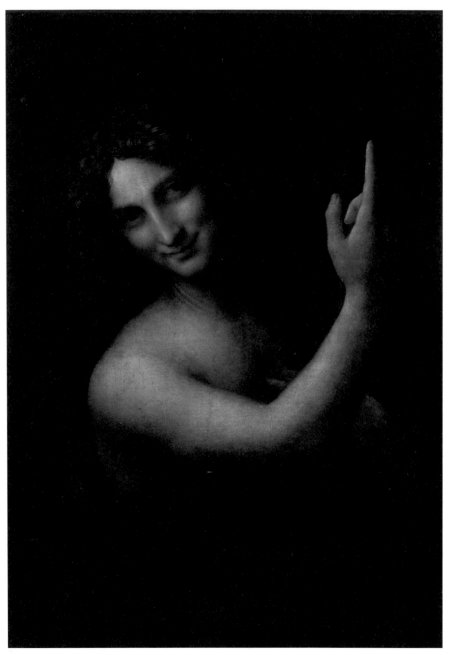

Leonardo's *Saint John the Baptist* was most likely one of the last paintings the artist made.

connected to the royal palace by an underground tunnel. Leonardo's new home was spacious and grand, with gardens and fig trees, a vineyard, and a fishing stream.

Francis respected Leonardo's talent as an artist. He was also impressed with Leonardo's depth of knowledge on so many subjects. It is believed that the young king used the underground tunnel to visit Leonardo nearly every night to talk about art and science.

Sadly, at about the age of sixty-five, Leonardo's health declined further. Arthritis caused him pain and interfered with his ability to paint. Although his body was growing

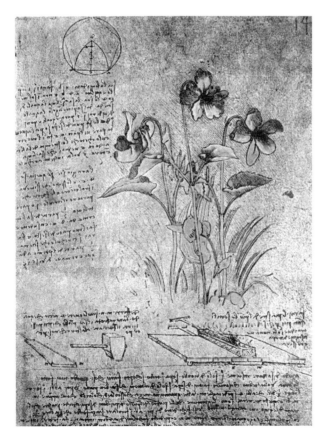

Over the years, Leonardo had filled thousands of pages with ideas and sketches.

older and weaker, his mind was still keen. It was important to Leonardo to continue studying the many subjects that interested him. "Iron rusts when it is not used," he wrote. "So, too, does inactivity sap the vigor of the mind."

About this time, Leonardo turned his attention once more to sorting the thousands of pages of notes he had accumulated over the last forty years. But the task seemed almost hopeless.

"This will be a collection without order," he wrote, "drawn from many pages which I have copied here, hoping to put them in order in their places, according to the subject with which they will deal, and I believe that before I am at an end of this, I will have to repeat the same thing many times."

Leonardo hoped he would at least be able to arrange his material according to subject, such as painting, voice, optics, the flight of birds, the horse, and the air. That way he could attempt to publish his ideas.

He made a schedule for himself and listed the chapter headings of the books he hoped to publish. But the task was just too much. His *Treatise on Painting* was the only collection of his ideas on one subject to be published, but it was published years after his death.

As time went on, Leonardo's arthritis worsened, and he could no longer paint or write. His friend Francesco Melzi worked as his assistant, adding finishing touches to paintings or taking dictation. By this time, Francesco had become Leonardo's closest and dearest friend. Shortly after their arrival in France, Salai had returned to Milan.

Perhaps Salai had grown distant from Leonardo or was jealous of his relationship with Francesco. Leonardo's friendship with Salai had never been smooth. After more than twenty years together, Leonardo once wrote, "Salai, I want to make peace with you, not war. No more war, I give in."

In April 1519, sixty-seven-year-old Leonardo dictated his will. He left a few things to Salai, his half brothers, friends, and servants. All the rest—his notebooks, paintings, property, and personal belongings—he left to Francesco Melzi.

Leonardo da Vinci died on May 2, 1519.

AFTERWORD

Leonardo lived in an age of change, discovery, and creativity, when the world was advancing at a remarkable rate. During Leonardo's lifetime, Christopher Columbus discovered the New World. Nicolaus Copernicus developed his theory that Earth rotates around the Sun. Some of the greatest artists of all time, Botticelli, Michelangelo, Raphael, and Titian, produced some of the world's masterpieces. Machiavelli's famous book, *The Prince,* was published. Only six months after Leonardo's death, Ferdinand Magellan would sail around the world. But perhaps no individual accomplished more than Leonardo da Vinci. He has left his mark on the art world for all time.

Nowhere is the legacy of Leonardo da Vinci felt more than in the areas of art and science. Leonardo's artistic talent was extraordinary. He captured the depth of human emotions and the natural world like no other artist of his time. His use of shadow and color and his meticulous calculations of mathematical proportions created a sense of three-dimensional perspective that was the very essence of Renaissance art.

Of the work produced, only a few paintings have survived. But his remarkable genius, combined with the new ideas of the Renaissance, have made a lasting impression on the world.

Leonardo was also a scientist in every sense of the word: researcher, experimenter, and inventor. His curiosity led him to question endlessly. He had a remarkable ability to observe and then to record exactly what he saw.

In addition, he believed that all things are connected. This belief led him to study an amazing range of scientific subjects. Many of his ideas were not understood until nearly two hundred years after his death.

Leonardo's revolutionary studies in anatomy, optics, and flight were some of his greatest scientific achievements. His ideas in engineering were far ahead of their time. His inventions, from futuristic vehicles to useful gadgets, still fascinate scientists.

Who knows what impact his work might have had if his research, sketches, inventions, and experiments had been discovered sooner—and in their entirety. But the surviving manuscripts, barely half of the total, were not published or even shared for many years after his death. These writings, however, serve as evidence that Leonardo da Vinci was more than a great artist. He was also one of the greatest scientific minds of all time.

Leonardo's Major Works: Where Are They Now?

The twenty surviving paintings created solely or in part by Leonardo are housed in museums in Italy, Poland, France, and the United States. Interestingly, there are two surviving copies of the *Virgin of the Rocks*. The original painting, which is in the Louvre Museum in Paris, France, displeased the monks who had commissioned it. Following a lengthy lawsuit, Leonardo agreed to paint a second version, which hangs in the National Gallery in London, England. The only Leonardo da Vinci painting in the United States is the portrait *Ginevra de'Benci*. Since 1967 it has been in the National Gallery in Washington, D.C.

The *Mona Lisa* is one of the few paintings that Leonardo ever finished completely. No one knows why he kept it, packing it up and moving it with him from Milan to Rome to France. When he died, he left his belongings, including the *Mona Lisa,* to his friend Francesco Melzi. Leonardo's patron Francis I acquired the famous portrait from Francesco. The *Mona Lisa* stayed in the French royal family for hundreds of years. At one point, it actually hung in a bathroom of the palace! The French royal family eventually gave the famous portrait to the Louvre Museum in Paris. Over the years, the painting has suffered from deterioration and has lost much of its original beauty.

On August 22, 1911, the world was shocked to learn

that someone had stolen the *Mona Lisa* from the Louvre. Nearly two years later, an antique dealer in Florence, Alfredo Geri, received a letter from a house painter named Vincenzo Peruggia. Vincenzo told Alfredo that he had the *Mona Lisa.* First Alfredo called the police. Then he took an art expert to Vincenzo's hotel. Sure enough, there in the bottom of the man's suitcase was the most famous painting in the world! It seems that Vincenzo had at one time worked in the Louvre. He evidently planned to return all of the Louvre's Italian paintings to Italy. The *Mona Lisa* was returned to the Louvre. The portrait attracts so many visitors that a special gallery was built to accommodate the enormous crowds.

The history of Leonardo's famed fresco, *The Last Supper,* has been a sad one. The painting began to flake and deteriorate even in Leonardo's lifetime. The experimental materials he had used to prepare the wall had not been successful. But other factors contributed to the declining condition of the painting, including wind and moisture. Sometime in the 1600s, a door was cut in the fresco wall, destroying part of the painting. Nearly one hundred years later, there were several attempts to restore that portion of the painting, but the restorers did such a poor job that they made the condition of the painting worse.

The Last Supper suffered more misfortune in 1796, when Napoléon Bonaparte's troops stored their horses in the monastery that houses the painting. To amuse themselves, the soldiers threw bricks at the wall, damaging the fresco. Then, during World War II (1939–1945), bombs destroyed most of the monastery. Nothing was left standing

except, remarkably, the wall depicting *The Last Supper.*

Over the years, there have been several attempts to restore *The Last Supper* to its original condition. In 1977 restorers began the painstaking task of cleaning mold, dirt, and soot from the fresco and removing layers of overpainting applied during previous restorations. Experts used X rays and infrared and ultraviolet sensors to determine which paint layers had actually been applied by Leonardo. This restoration project lasted twenty-two years. Although the result is a much cleaner and brighter painting, many art historians consider the restored version of *The Last Supper* to be more the work of restorers than of Leonardo da Vinci.

In addition to his surviving paintings, Leonardo left the art world his only published work on a single subject, the *Treatise on Painting.* He originally planned to produce eight books on the major areas of painting, including anatomy, proportion, and nature. He never succeeded in doing so. The *Treatise on Painting* was published in 1651, long after Leonardo's death.

What has become of the vast collection of Leonardo's notebooks? He had hoped to organize and publish them, but his life's work remained in unorganized bundles of papers, some tied with ribbon and string, others bound in leather notebooks or folders. Francesco Melzi hoped that he could accomplish what Leonardo did not by organizing and cataloguing the nearly 13,000 pages of notes. But, like Leonardo, Francesco was never able to complete the project, even with the help of two assistants.

When Francesco died in 1570, he left his friend's

priceless collection to his son, Orazio. Sadly, Orazio had little interest in continuing his father's work. He put the boxes of notes in a cupboard in the attic and thought no more about them.

When Orazio's tutor, Lelio Gavardi, learned that Leonardo's writings were in the attic, he convinced Orazio to give him nearly thirteen volumes of the notebooks. He then sold them to the grand duke of Tuscany.

When the word spread that the Melzi family owned such a vast collection of Leonardo's work, people hurried to Milan in hopes of buying some of the notes. Some people actually ripped pages from the treasured notebooks. Eventually, thousands of unbound sheets and notebooks were scattered throughout Europe.

Nearly half of Leonardo's notebooks have been lost or destroyed. Over the years, the surviving notes have been rearranged and some pages even cut and pasted into a different order. Eventually, many of the notes were grouped together into ten different collections. One of these collections is with the British royal family at Windsor. Another is in the Victoria and Albert Museum in London, England. Other manuscript collections are in libraries in Italy, Spain, and France. Some manuscript pages are on display in museums, such as the Metropolitan Museum of Art in New York City and the Louvre in Paris. Only one collection of manuscripts, called the Codex Leicester, is owned by an individual. Microsoft founder Bill Gates bought the collection in 1994 for $30 million, the most ever paid for a manuscript. He used the notes to help produce a CD-ROM on the life and work of Leonardo da Vinci.

LOCATIONS OF MAJOR WORKS
BY LEONARDO DA VINCI

Biblioteca Reale in Turin, Italy
Self-Portrait

The Louvre in Paris, France
La Belle Ferronière
Mona Lisa
Portrait of Isabella d'Este
Saint John the Baptist
Virgin of the Rocks (original)
Virgin and Child with Saint Anne

National Gallery in London, England
Virgin of the Rocks

National Gallery in Washington, D.C.
Ginevra de' Benci

National Museum in Kraków, Poland
Lady with an Ermine

The Santa Maria delle Grazie Monastery in Milan, Italy
The Last Supper

The Uffizi Galleries in Florence, Italy
Adoration of the Magi
Annunciation
Baptism of Christ

Leonardo in His Own Words

"Though I may not . . . be able to quote other authors, I shall rely on that which is much greater and more worthy: on experience."

"Those who are in love with practice without knowledge are like the sailor who gets into a ship without a rudder or compass and who never can be certain whether he is going."

"The painter who draws merely by practice and by eye, without any reason, is like a mirror which copies every thing placed in front of it without being conscious of their existence."

"What is fair in men, passes away, but not so in art."

"Men and words are ready made, and you, O Painter, if you do not know how to make your figures move, are like an orator who knows not how to use his words."

"Science is the observation of things possible, whether present or past."

"Wisdom is the daughter of experience."

"If you understand that old age has wisdom for its food, you will so conduct yourself in youth that your old age will not lack for nourishment."

"As a day well spent procures a happy sleep, so a life well employed procures a happy death."

TIMELINES

Leonardo

1452	Born on April 15 at 10:30 P.M.
1465	Joins Verrocchio's workshop in Florence
1472	Earns the title of master craftsman and joins a painter's guild
1472	Begins painting part of *Baptism of Christ*
1474	Works on *Annunciation*
1478	Receives his first commission as an independent artist; paints *Ginevra de' Benci*
1481	Begins work on *Adoration of the Magi*
1482	Arrives in Milan
1483	Begins painting the *Virgin of the Rocks;* paints *Lady with an Ermine;* begins keeping notebooks
1490	Creates his *Masque of the Planets* for Ludovico Sforza; paints *La Belle Ferronière;* takes Gaicomo (Salai) into his workshop
1493	Presents his full-size clay model of a horse for Ludovico; Caterina comes to live with him
1495	Begins painting *The Last Supper*
1500	Moves back to Florence
1502	Works for Cesare Borgia
1503	Returns to Florence and begins work on the *Battle of Anghiari;* possibly begins work on the *Mona Lisa*
1506	Returns to Milan at the request of French king Louis XII
1507	Francesco Melzi joins Leonardo's workshop
1508	Begins painting the *Virgin and Child with Saint Anne*
1513	Moves to Rome; paints *Saint John the Baptist*
1516	Moves to France
1519	Dies on May 2

Renaissance Europe

1303 Giotto begins his frescoes in the Scrovegni Chapel.

1416 Donatello sculpts his *Saint George Killing the Dragon*.

1425 Masaccio begins painting *The Tribute Money*.

1435 Donatello completes his sculpture *David*.

1438 Gutenberg invents the printing press.

1469 Lorenzo de' Medici rules Florence until 1492.

1473 The Sistine Chapel is erected by Pope Sixtus IV.

1480 Ludovico Sforza seizes power in Milan.

1484 Botticelli paints *Birth of Venus*.

1492 Columbus discovers the New World.

1499 Amerigo Vespucci makes his first voyage to South America.

1508 Michelangelo begins painting the ceiling of the Sistine Chapel.

1509 Raphael beings painting *The School of Athens*.

1511 Titian begins painting *Sacred and Profane Love*.

1513 Niccoló Machiavelli writes *The Prince*.

1515 Francis I becomes king of France.

1517 Martin Luther makes an official protest against the Catholic Church, ushering in the Protestant Reformation.

1519 Ferdinand Magellan sets sail for his voyage around the world.

1521 Hernán Cortés encounters the Aztecs in what is now Mexico City.

1543 Copernicus's statement that Earth revolves around the Sun is published.

Some of the dates in these timelines, such as when Leonardo and other artists worked on many of their paintings, are not exactly known.

Artists of the
Italian Renaissance

Botticelli (1444–1510) was a Florentine painter who had a unique Renaissance style. His two most famous paintings, *Birth of Venus* and *The Primavera,* show the flowing lines his work is known for. Unlike many Renaissance artists, Botticelli did not choose to paint exactly realistic human figures. Instead, he painted people with gracefully long bodies and limbs. His early paintings feature both religious and mythical themes. Later in his life he felt called to paint only religious scenes and burned some of his earlier mythical paintings.

Donatello (1386?–1466?) from Florence is considered one of the greatest sculptors of all time. He developed a sculpting technique known as flat relief that continues to be used by modern artists. With this technique, an artist carves shallow figures out of a flat surface such as stone. The artist then adds the illusion of depth by carving in a background. One of Donatello's well-known works, *Saint George Killing the Dragon,* is an example of this style. Donatello's sculptures were also famed for the realistic way in which they represented the human form.

Giotto (1267?–1337) began his career as an artist when the Byzantine style of painting was popular in Europe. Artists of this style portrayed religious scenes that seem flat and unrealistic. Giotto developed a new style that revolutionized European art. He began painting realistic scenes and people while also experimenting with the use of natural lighting. Some of his most famous works are the frescoes in the Scrovegni Chapel in Padua, Italy, that show scenes from the life of Jesus and Mary.

Masaccio (1401–1428) is considered by some people to be one of the first great painters of the Italian Renaissance. In his paintings, he introduced the use of perspective based on

mathematical calculations. Masaccio was born in San Giovanni de Valdarno, Italy. He studied in Florence and was considered a great artist by the age of twenty-one. A series of frescoes in the Brancacci Chapel of the Church of Santa Maria del Carmine in Florence is considered his finest work. This series includes *The Tribute Money.*

Michelangelo (1475–1504) was a great rival of Leonardo's. He made a name for himself as a painter, sculptor, and architect, and became one of the most well-known artists in European history. Michelangelo's paintings give off a sense of power and spirituality. He is famous for his realistic depictions of people in his paintings and sculptures. His most famed works are the sculpture called *David* and his paintings on the ceiling and walls of the Sistine Chapel. The scene that many people know from the Sistine Chapel is called *The Creation of Adam.*

Raphael (1483–1520) was born in Urbino, Italy, where his father was a painter for the duke. Raphael built upon the techniques of Leonardo and Michelangelo. He created paintings famed for their strong sense of balance and harmony. Toward the end of Raphael's life, Pope Julius II asked him to work in Rome, and he stayed there until he died. One of his best works, *The School of Athens,* appears in the Vatican. This large fresco shows scholars and scientists from ancient Greece gathered together under an archway. It is believed that Raphael modeled the figure of the Greek philosopher Plato on Leonardo da Vinci.

Titian (1487–1576) was a Venetian painter who began his career near the end of Leonardo's life. During Titian's seventy years as an artist, he became one of the most influential painters in the history of art. For nearly two hundred years after he died, his style continued to influence European painting. He used bright colors and bold brush strokes and created many vivid portraits. In these portraits he mixed the person's true appearance with what he considered their "ideal persona," or the true identity of the person within.

LEARN MORE ABOUT
LEONARDO DA VINCI

Books
Nonfiction
Herbert, Janis. *Leonardo da Vinci for Kids: His Life and Ideas: 21 Activities.* Chicago: Chicago Review Press, 1998.

Leonardo da Vinci. *The Notebooks of Leonardo da Vinci.* Edited by Irma A. Richter. Oxford: Oxford University Press, 1998.

Stanley, Diane. *Leonardo da Vinci.* New York: Morrow Junior Books, 1996.

Fiction
Fritz, Jean. *Leonardo's Horse.* New York: Penguin Putnam, 2001. Fritz retells two true stories: Leonardo's attempt to create an enormous horse statue for the Duke of Milan and American Charles Dent's plan to recreate and complete the unfinished statue in the twentieth century.

Konigsburg, E. L. *The Second Mrs. Gioconda.* New York: Aladin Books, 1998. Leonardo's young assistant Salai tells the tale of how the great artist came to paint the *Mona Lisa*.

Websites
Leonardo da Vinci: Scientist, Inventor, Artist
<http://www.mos.org/leonardo>
This interactive website from the Museum of Science allows readers to explore Leonardo's life, inventions, and artistic techniques.

The Leonardo Museum
<http://www.leonet.it/comuni/vinci>
The Leonardo Museum, located in Leonardo's hometown of Vinci, has a website devoted to the artist's life and times.

Sources for Quotations

11 Serge Bramly, *Leonardo: The Artist and the Man* (New York: Penguin Books, 1988), 37, quoting from a Da Vinci family document housed in the Florence Archives.

24 Michael White, *Leonardo: The First Scientist* (New York: St. Martin's Press, 2000), 67, quoting Leonardo da Vinci, the Codex Atlanticus.

28 Bramly, 84.

32 Bramly, 144, quoting Leonardo, the Codex Atlanticus.

38 Bramly, 174–176, quoting Leonardo, the Codex Atlanticus.

39 Bramly, 174–176, quoting Leonardo, the Codex Atlanticus.

40 Bramly, 174–176, quoting Leonardo, the Codex Atlanticus.

44 Bramly, 83, quoting Leonardo, the Codex Arundel.

47 Bramly, 207, quoting Leonardo, notes located in the British Museum.

52–53 Bramly, 223, quoting Leonardo, Notebook C.

54 White, 135, quoting Leonardo, Notebook C.

56 Bramly, 243, quoting Leonardo, the Forester III notebook.

57 Bramly, 244, quoting Leonardo, notes located in South Kensington, Britain.

58 Bramly, 274, quoting Leonardo, Notebook H.

60 Bramly, 288, quoting Leonardo, Notebook B.

63 Bramly, 277, quoting Leonardo, the Forester II notebook.

65 White, 150, quoting R. Marcolonga, *Studi Vinciani, Memorie sulla geometrica e sulla meccanica di Leonardo da Vinci (Vinciani Studies: Writings on the Geometry and Mechanics of Leonardo da Vinci).* (Naples, 1937).

68–69 White, 206, quoting Leonardo, the Codex Atlanticus.

73 Bramly, 338, quoting Leonardo, Notebook B.N. 2038.

77 White, 267, quoting Leonardo, Quaderni, vol I.

92 White, 258, quoting Leonardo, the Codex Atlanticus.

92 White, 259, quoting Leonardo, the Codex Arundel.

93 Bramly, 228, quoting Leonardo, the Codex Atlanticus.

101 Leonardo da Vinci, *The Notebooks of Leonardo da Vinci,* vol. 1, ed. Jean Paul Richter (New York: Dover Publications, 1970), 15

101 Leonardo, *Notebooks,* vol. 1, 18.

101 Leonardo, *Notebooks,* vol. 1, 18.

101 Leonardo, *Notebooks,* vol. 1, 326.

101 Leonardo, *Notebooks,* vol. 1, 331.

101 Leonardo da Vinci, *The Notebooks of Leonardo da Vinci,* vol. 2, ed. Jean Paul Richter (New York: Dover Publications, 1970), 288.

101 Leonardo, *Notebooks,* vol. 2, 288.

101 Leonardo, *Notebooks,* vol. 2, 293.

101 Leonardo, *Notebooks,* vol. 2, 293.

SELECTED BIBLIOGRAPHY

Bramly, Serge. *Leonardo: The Artist and the Man.* New York: Penguin Books, 1988.

Brown, David Alan. *Leonardo da Vinci: Origins of a Genius.* New Haven, CT: Yale University Press, 1998.

Clark, Kenneth. *Leonardo da Vinci.* New York: Penguin Books, 1993.

Costantino, Maria, and Aileen Reid. *Leonardo.* New York: Mallard Press, 1991.

Kemp, Martin. *Leonardo da Vinci: The Marvellous Works of Nature and Man.* Cambridge, MA: Harvard University Press, 1981.

Leonardo da Vinci. *The Notebooks of Leonardo da Vinci.* 2 vols. Edited by Jean Paul Richter. New York: Dover Publications, 1970.

Letze, Otto, and Thomas Buchsteiner, eds. *Leonardo da Vinci: Scientist, Inventor, Artist.* New York: Distribution Art Publishers, 1997.

McLanathan, Richard. *Images of the Universe: Leonardo da Vinci, the Artist as Scientist.* New York: Doubleday and Co., 1966.

Nuland, Sherwin B. *Leonardo da Vinci.* New York: Viking, 2000.

Raboff, Ernest. *Leonardo da Vinci.* New York: J. B. Lippincott, 1978.

Romei, Francesca. *Leonardo da Vinci: Artist, Inventor, and Scientist of the Renaissance.* New York: Peter Bedrick Books, 1994.

Turner, A. Richard. *Inventing Leonardo.* New York: Alfred A. Knoff, 1993.

Vezzosi, Alessandro. *Leonardo da Vinci: The Mind of the Renaissance.* New York: Harry N. Abrams, 1996.

White, Michael. *Leonardo: The First Scientist.* New York: St. Martin's Press, 2000.

INDEX

About the Author

Barbara O'Connor is the author of several Trailblazer Biographies, including *Barefoot Dancer: The Story of Isadora Duncan, Katherine Dunham: Pioneer of Black Dance,* and *The Soldiers' Voice: The Story of Ernie Pyle.* Her award-winning novels include *Moonpie and Ivy* and *Me and Rupert Goody.* Ms. O'Connor lives in Duxbury, Massachusetts.